OUR WILD TAILS

Our Wild Tails

THE ADVENTURES OF
HENRY & BALOO

BY CYNTHIA BENNETT

GIBBS SMITH
TO ENRICH AND INSPIRE HUMANKIND

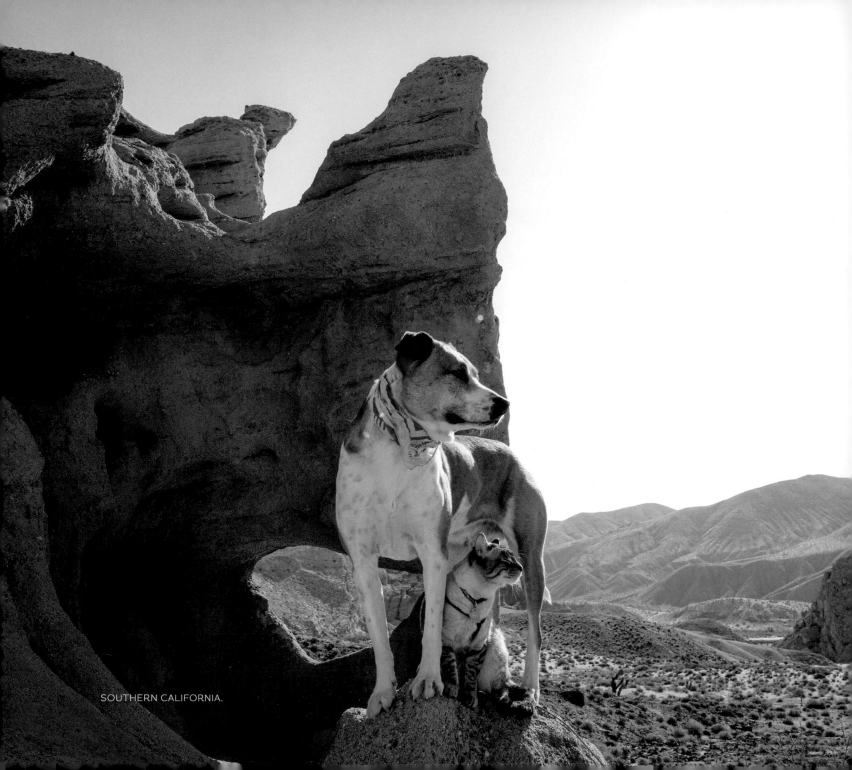

SOUTHERN CALIFORNIA.

DEDICATED

—

TO MY MOTHER

AND TO MY GRANDFATHER, BOPPA,

 instilled in me a love of animals and a respect for nature.

CONTENTS

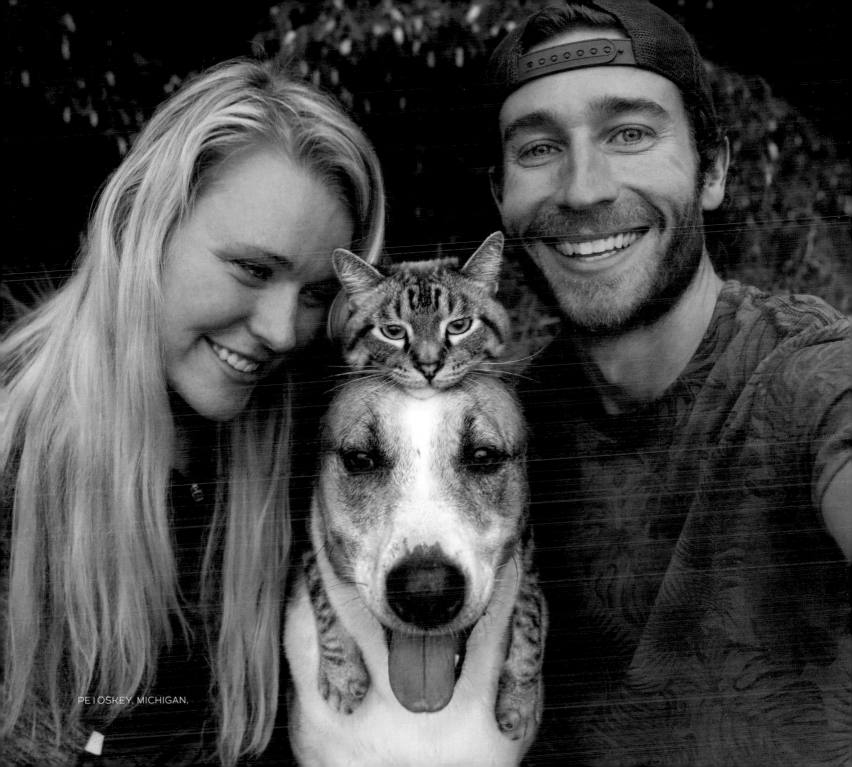
PETOSKEY, MICHIGAN.

LOVE

FLOWERS BEST IN OPENNESS
and freedom.

—EDWARD ABBEY

Cats and dogs, historically, have a strained relationship at best—but Henry and Baloo seem oblivious to their enemy status. Breaking all cat and dog stereotypes, they love and support one another despite their differences.

More than two years in the making, with more than one hundred never-before-seen photographs, *Our Wild Tails: The Adventures of Henry & Baloo* will take you through eleven states: across the Great American West, to the Pacific Ocean, and back again.

Join us on this epic adventure and learn about the very beginnings of our wild tails.

Cynthia Bennett

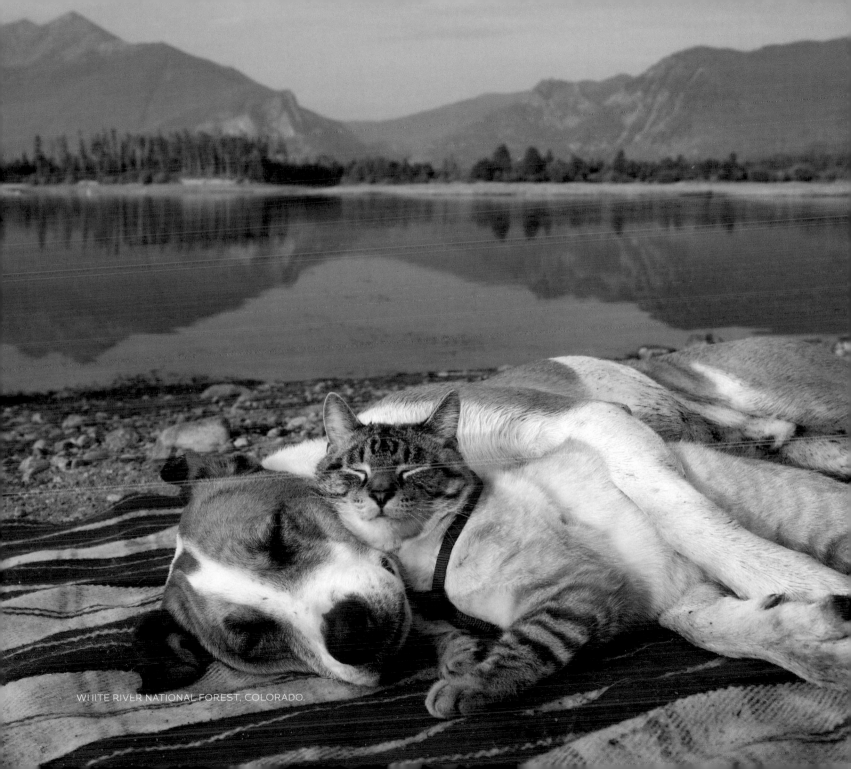

WHITE RIVER NATIONAL FOREST, COLORADO.

Beginnings

IT ALL STARTED WITH HENRY. HE'S THE REAL GLUE OF OUR FAMILY, ALWAYS BRINGING US TOGETHER AND KEEPING US CLOSE. WE WANTED TO ADOPT A DOG BECAUSE THERE ARE SO MANY ANIMALS WHO NEED OUR HELP.

We knew if we searched long enough we would eventually find the right fit for our family. Walking into yet another adoption event, I was so nervous, hoping that this time we would find the right hiking pup for us. As soon as we sat in Henry's pen, he plopped down and went belly up, stealing our hearts that very moment. There was absolutely no way we were going home without him. I mean, how could we not adopt that sweet boy?

While anxiously awaiting Henry's paperwork, we heard a couple say "Awe, poor guy is sad that he didn't get adopted," as he scaled his pen attempting to follow us, thinking he was being left behind. "Don't worry, Buttercup [Henry's

shelter name], you're coming with us, bud!" I exclaimed, with the biggest smile on my face. His fears were soon forgotten as we hopped into Andre's truck and headed to Henry's forever home. There was only a light dusting of snow on the ground, but enough for us to leave footprints and paw prints side by side. A sign of so many good things to come.

About a week after adopting Henry, we took him on his first hike in Colorado Springs—crossing our fingers that he would love climbing mountains as much as we do. Turns out, he loves it more. Like, way more. Without hesitation, he bounded up the tallest rock in sight, quickly earning the nickname Little Mountain Goat. We spent the next few seasons hiking, camping, and exploring all over Colorado, and Henry never missed a beat.

While he was our perfect mountain dog, Henry struggled with severe separation anxiety, showing signs of it from day one when he scaled the side of his pen on adoption day. Alone time for him was anything but relaxing. Instead of taking a nice nap, Henry would shake nonstop, hyperventilate, and refuse water or any treat we tried giving him. It got so bad that we were becoming concerned about his health. After three years of showing little improvement, we decided it was time to find Henry a buddy to keep him company and to ease his stress. We knew he would want a friend that could join us on all our adventures, but Andre and I weren't quite ready for another pup. So we began the search for an adoptable adventure kitten. That's where Baloo comes in!

EUGENE, OREGON. EXPLORING NEW ROADS AND FORESTS.

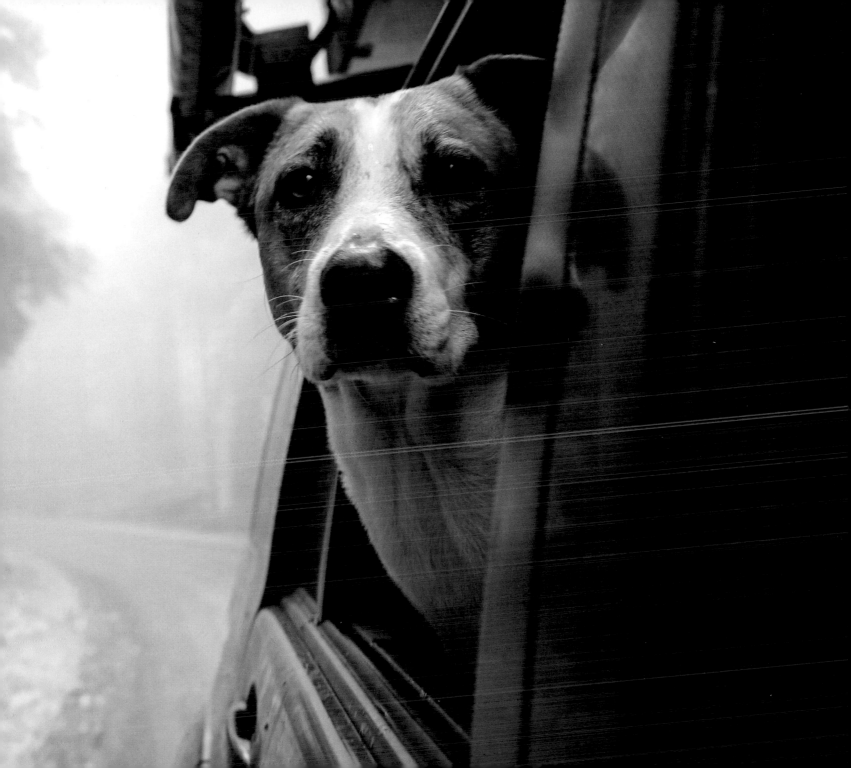

MAY YOUR TRAILS BE

CROOKED, WINDING,

LONESOME, DANGEROUS, LEADING

TO the most amazing view.

MAY YOUR MOUNTAINS

RISE INTO AND ABOVE THE CLOUDS.

—EDWARD ABBEY

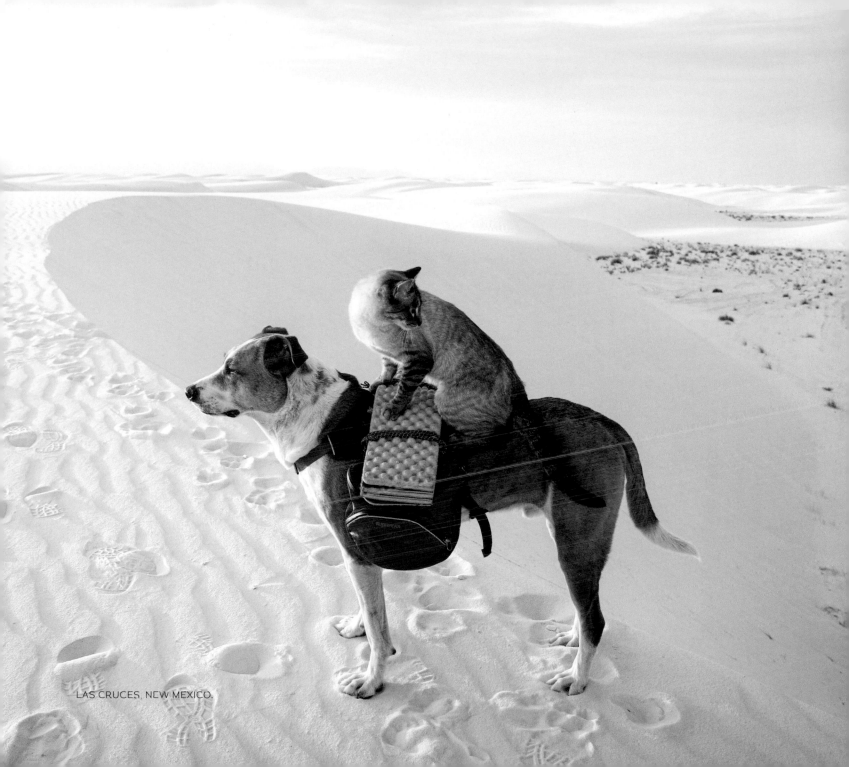

LAS CRUCES, NEW MEXICO.

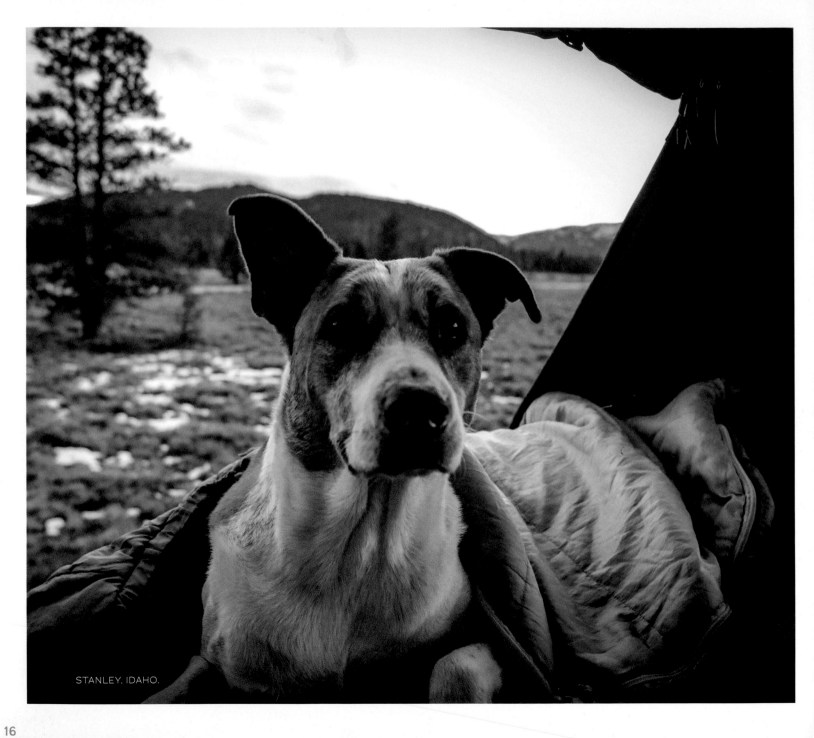

STANLEY, IDAHO.

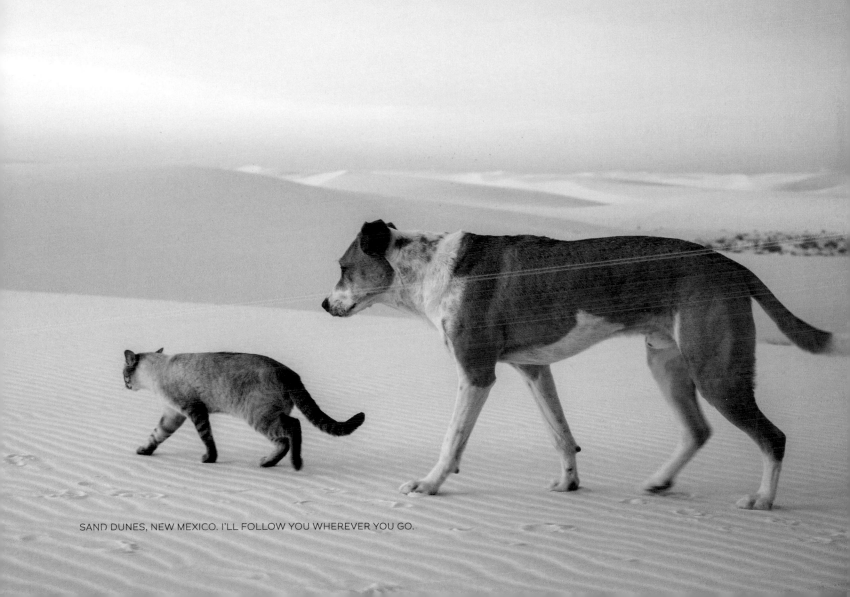

SAND DUNES, NEW MEXICO. I'LL FOLLOW YOU WHEREVER YOU GO.

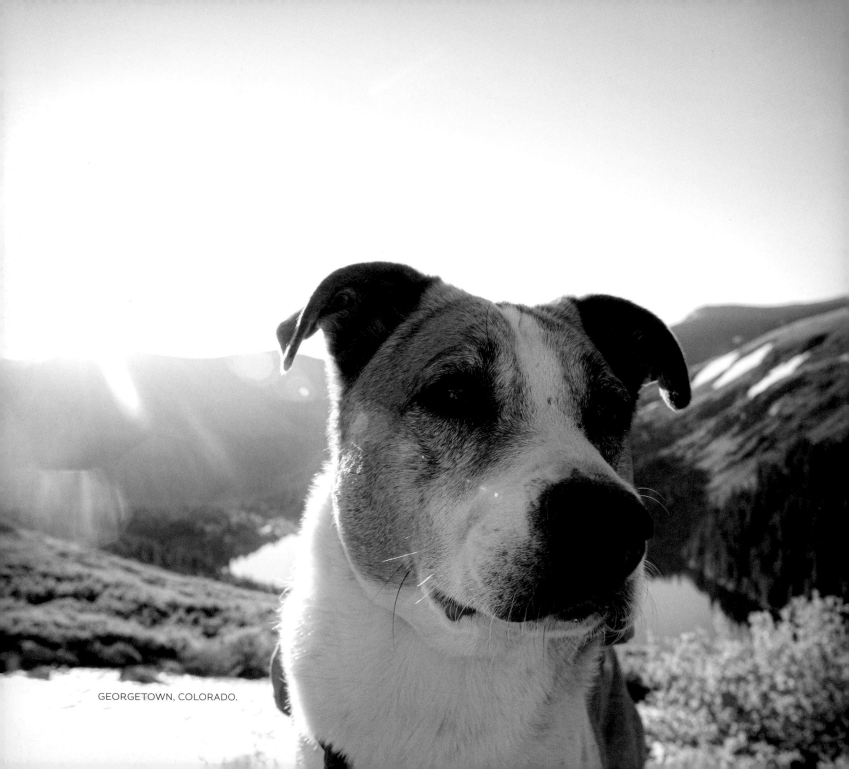

GEORGETOWN, COLORADO.

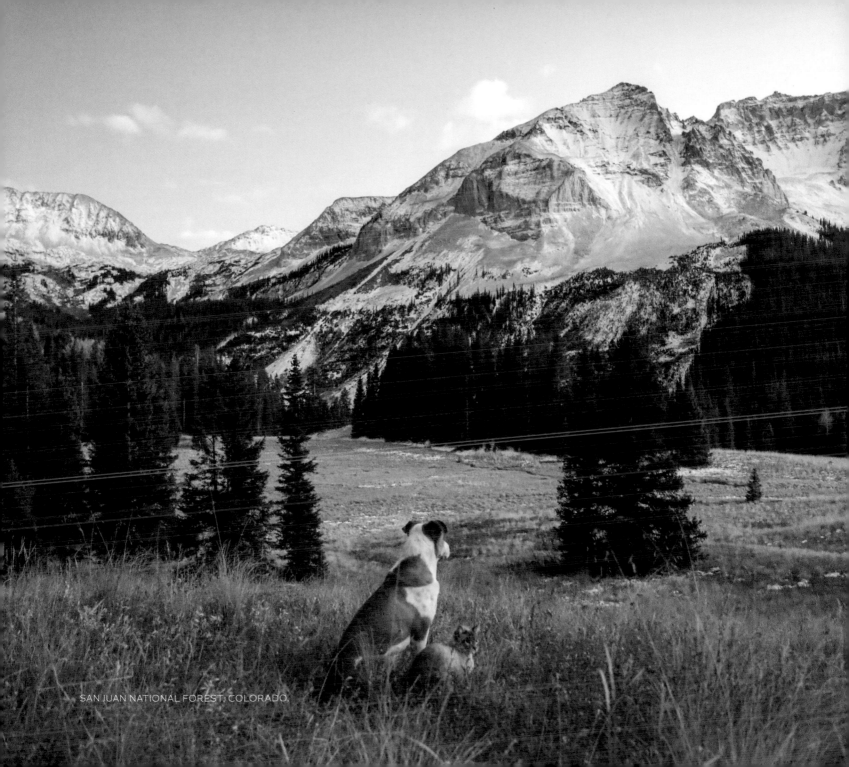

SAN JUAN NATIONAL FOREST, COLORADO.

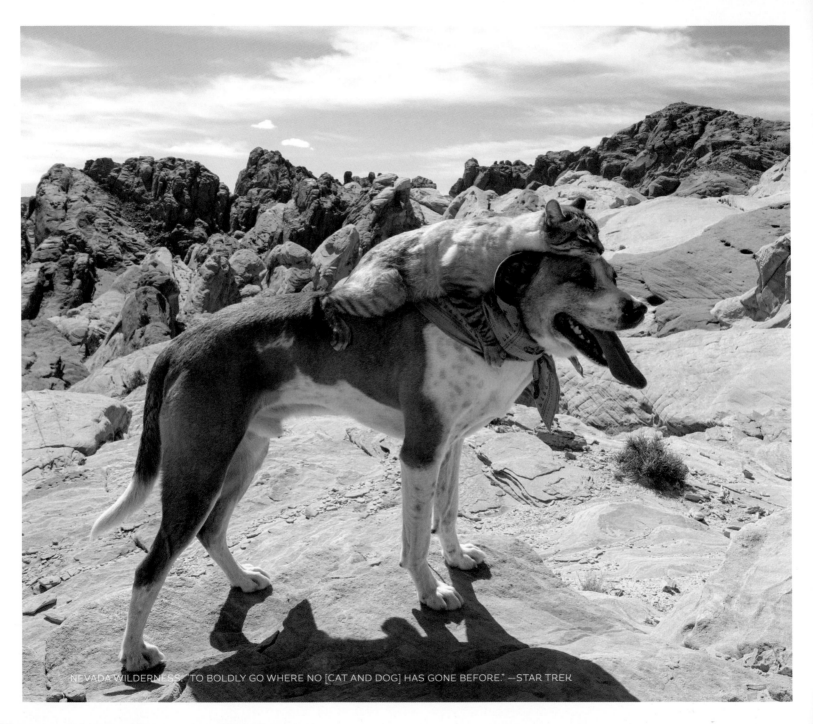

NEVADA WILDERNESS. "TO BOLDLY GO WHERE NO [CAT AND DOG] HAS GONE BEFORE." —STAR TREK

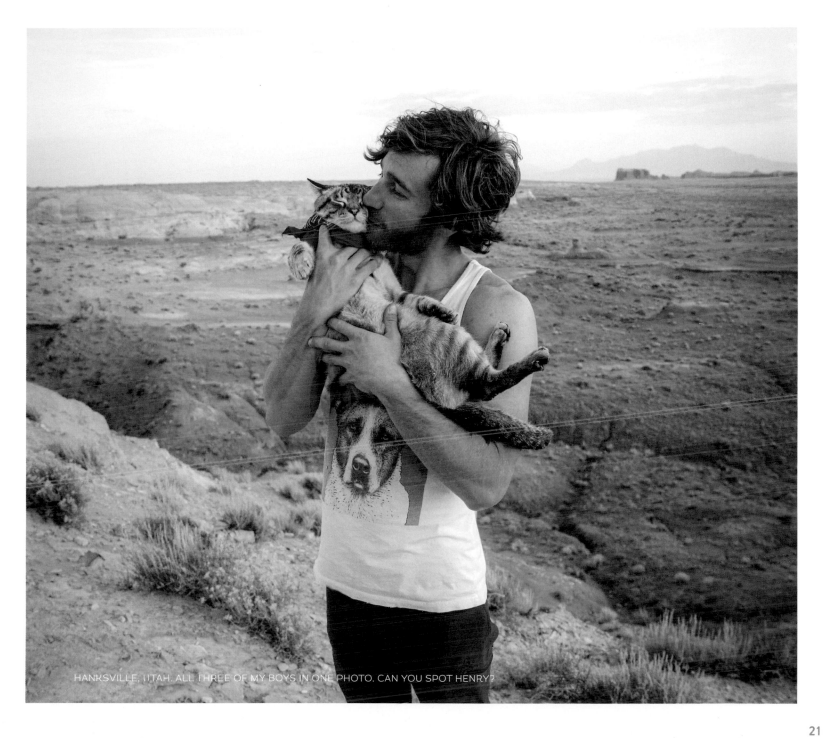

HANKSVILLE, UTAH. ALL THREE OF MY BOYS IN ONE PHOTO. CAN YOU SPOT HENRY?

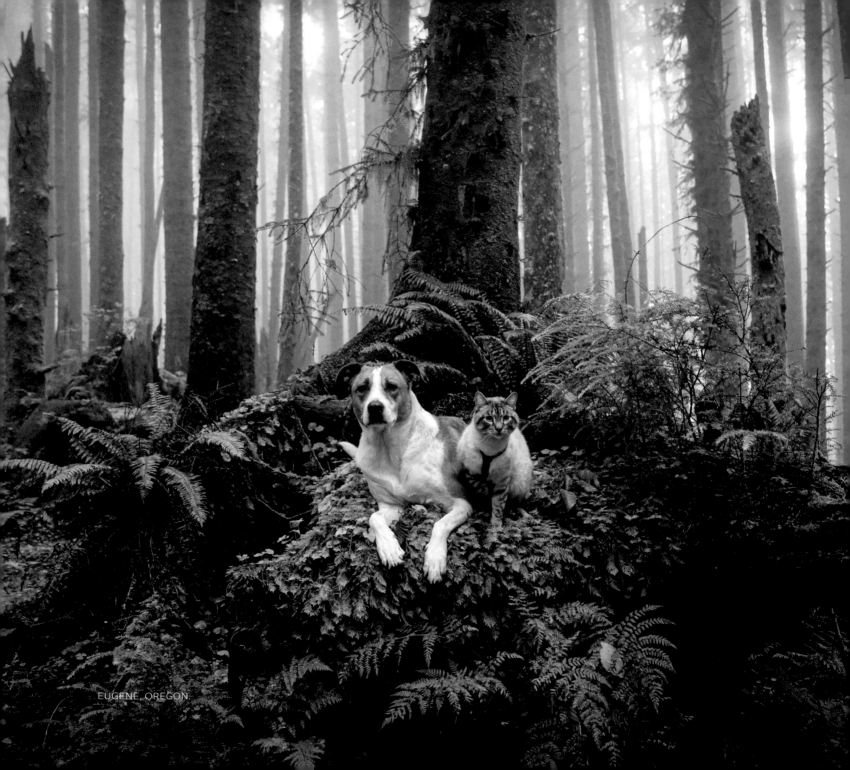

EUGENE, OREGON.

THE TREES WERE

FRIENDLY,

THEY GAVE ME REST

shadowed refuge.

—GIRL IN THE WOODS:
A Memoir, by Aspen Matis

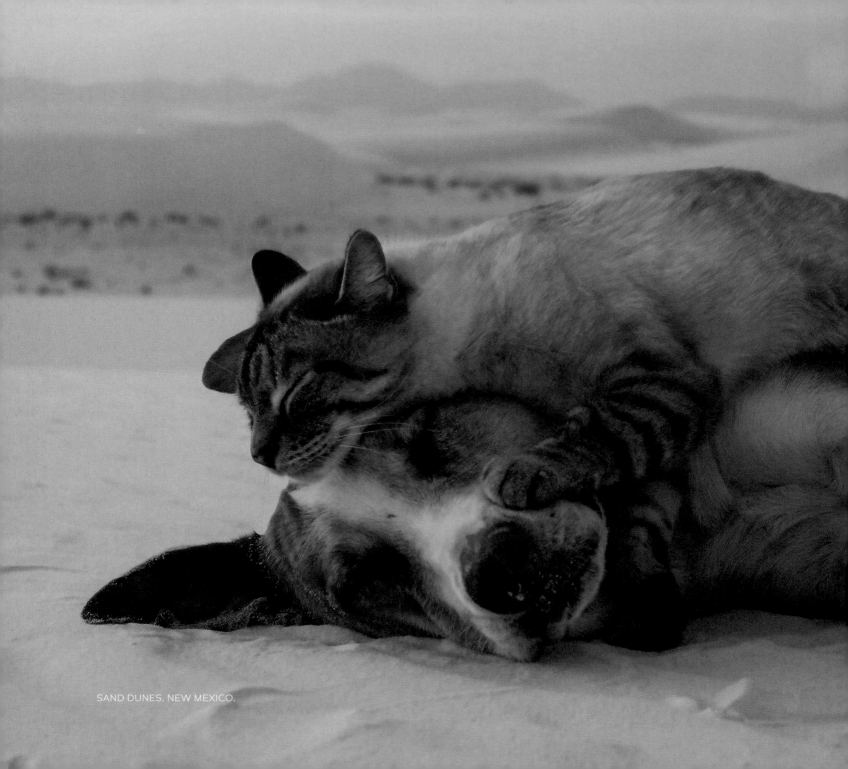

SAND DUNES, NEW MEXICO.

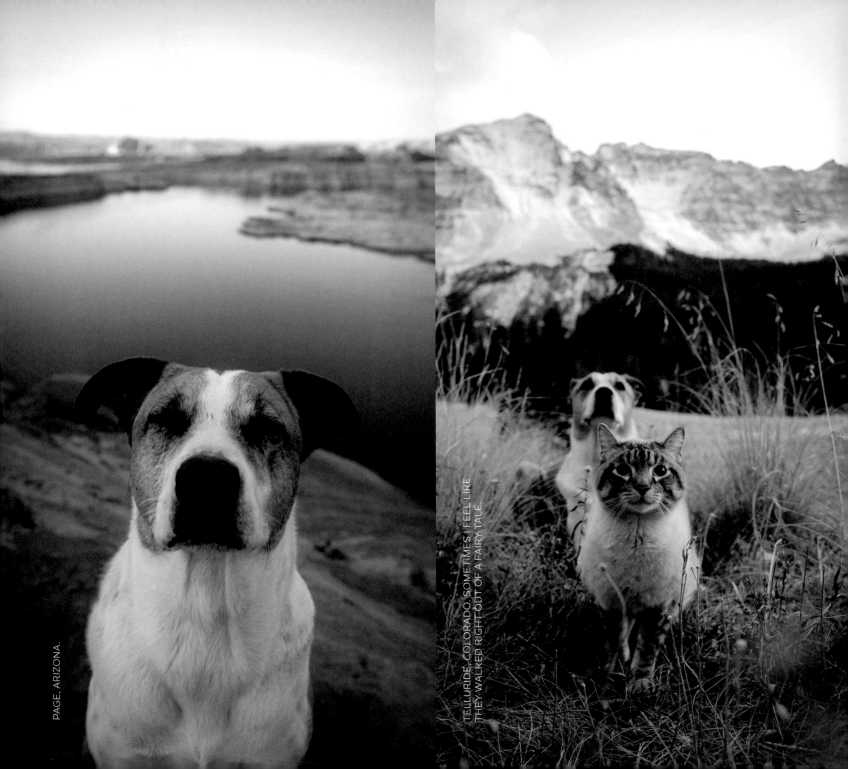

PAGE, ARIZONA.

TELLURIDE, COLORADO. SOMETIMES I FEEL LIKE
THEY WALKED RIGHT OUT OF A FAIRY TALE.

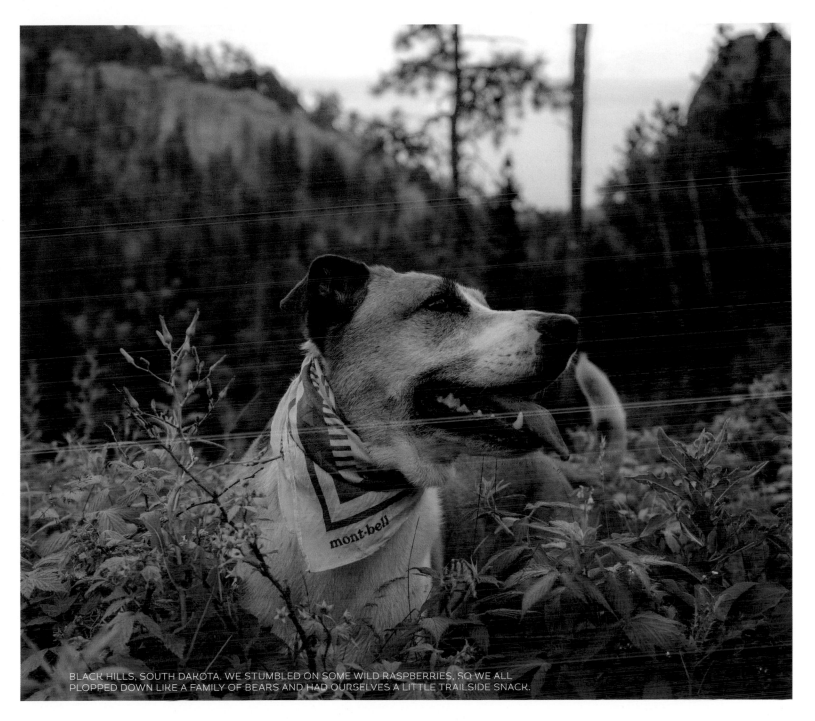

BLACK HILLS, SOUTH DAKOTA. WE STUMBLED ON SOME WILD RASPBERRIES, SO WE ALL PLOPPED DOWN LIKE A FAMILY OF BEARS AND HAD OURSELVES A LITTLE TRAILSIDE SNACK.

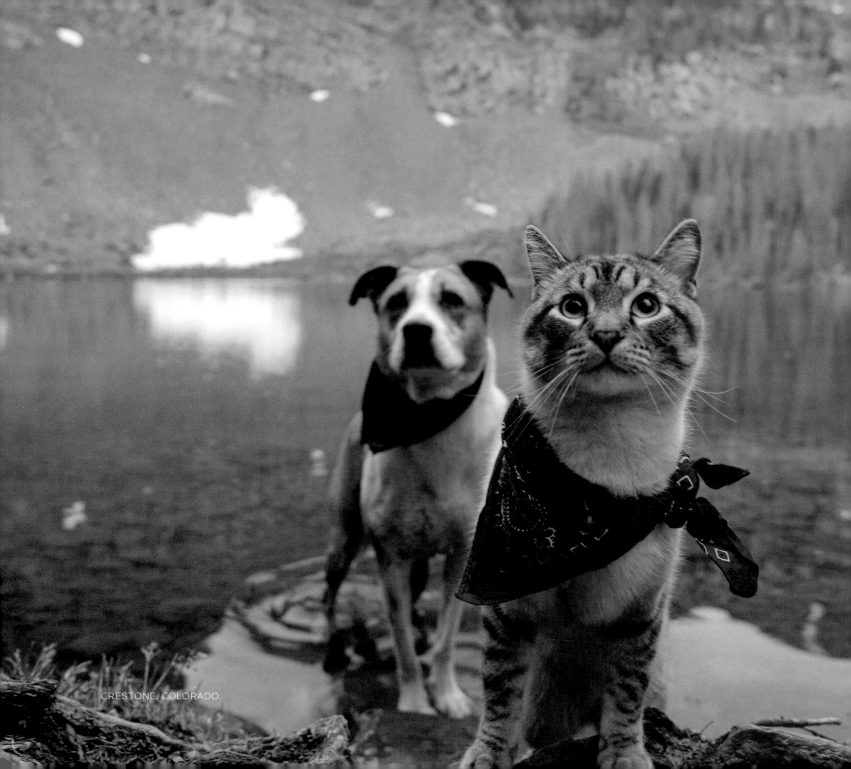
CRESTONE, COLORADO.

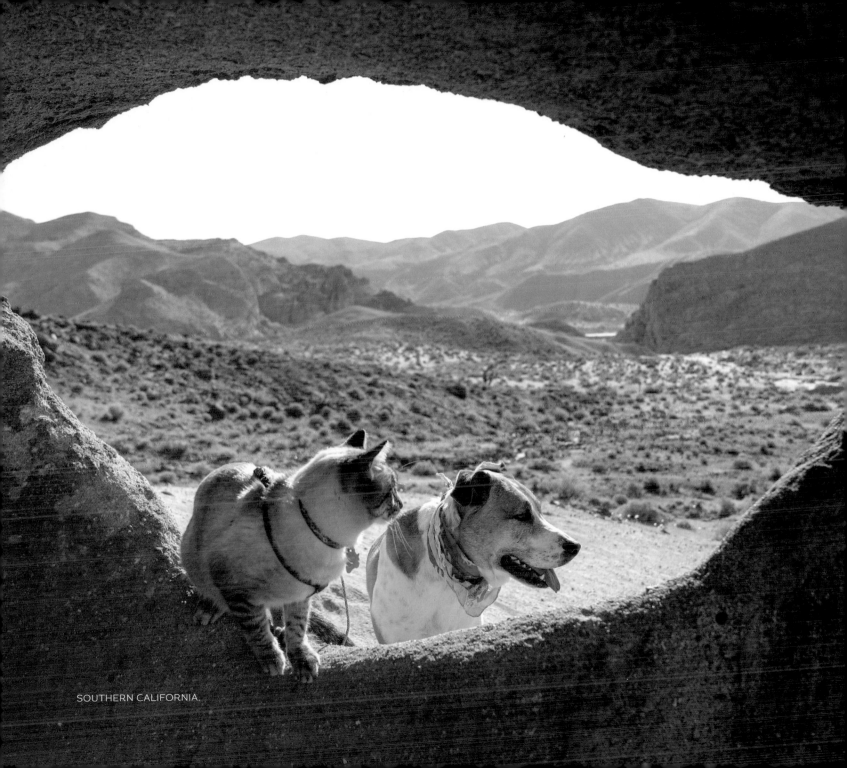

SOUTHERN CALIFORNIA.

FORMING OUR PACK

— BALOO —

WE SEARCHED FOR MORE THAN FOUR MONTHS TO FIND OUR NEW FURKID! SOME KITTENS WERE TOO NERVOUS, SOME WERE TOO ROWDY, BUT YETI (BALOO'S SHELTER NAME) WAS JUST RIGHT. I KNEW WITHIN SECONDS THAT HE WAS ABSOLUTELY PERFECT AND *THE* ONE.

The first time Baloo and I met, I walked into his room at the Evergreen Protective Animal League cat sanctuary, and he immediately jumped out of a pile of his siblings and ran straight to me. "Is this Yeti?" I asked. You see, in his adoption picture, one of his eyes was almost completely shut and looked like it could be a serious medical issue. But the kitten staring up at me had two bright, healthy eyes. "Yes, that's Yeti!" she told me. Not wasting one second, I scooped him up and slowly started rocking him from side to side, gazing into his eyes. And as corny as this sounds, I feel in that moment that Baloo chose us.

He already showed the top characteristic I was looking for in a potential adventure cat: eye contact. Eye contact is super important because it demonstrates trust and that an animal is interested in what you're doing. It's one of the reasons why dogs are easier to train than most cats!

Other traits I look for are confidence, curiosity, and an even temperament. Wanting to learn more about B, I put him down to play with his siblings—and he passed with flying colors. He'd play but not get too rambunctious. He was calm but not timid. When I talked to him, he'd talk back. When I called him, he'd give me eye contact. And at one point, he stopped playing to jump up on an ottoman just to get more attention from me. Adopting Baloo was one of the easiest decisions we've ever made.

We left their room to finalize B's adoption and as I was filling out the paperwork, something caught my eye. I turned to see Baloo standing at the glass door, looking out at me. Not a single one of his siblings was there, only Baloo. Of course, tears started immediately flowing as reality hit: Baloo was actually coming home with us. We had found the missing piece to our family puzzle.

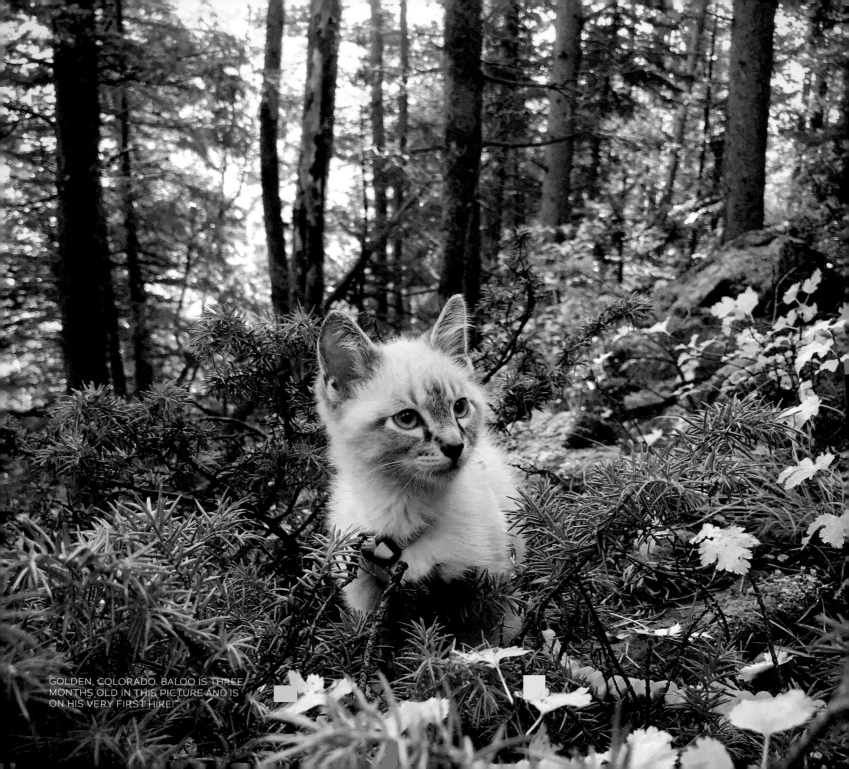

GOLDEN, COLORADO. BALOO IS THREE MONTHS OLD IN THIS PICTURE AND IS ON HIS VERY FIRST HIKE!

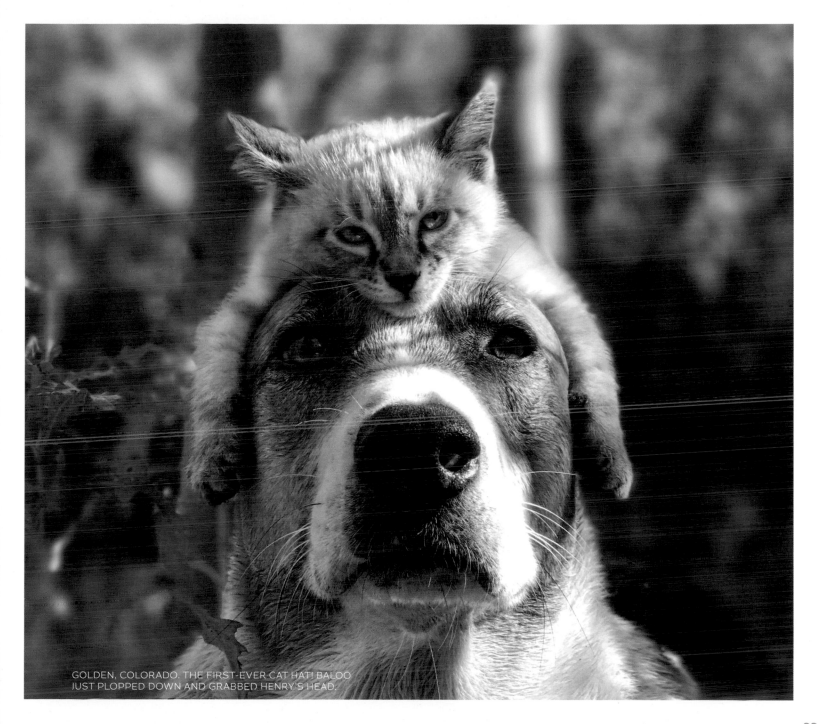

GOLDEN, COLORADO. THE FIRST-EVER CAT HAT! BALOO
JUST PLOPPED DOWN AND GRABBED HENRY'S HEAD.

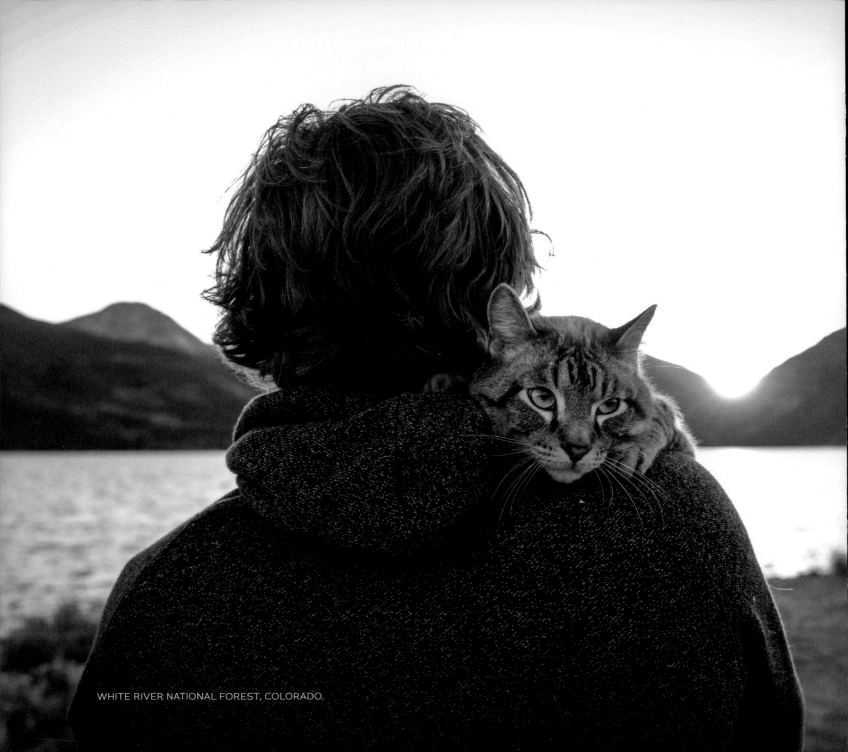

WHITE RIVER NATIONAL FOREST, COLORADO.

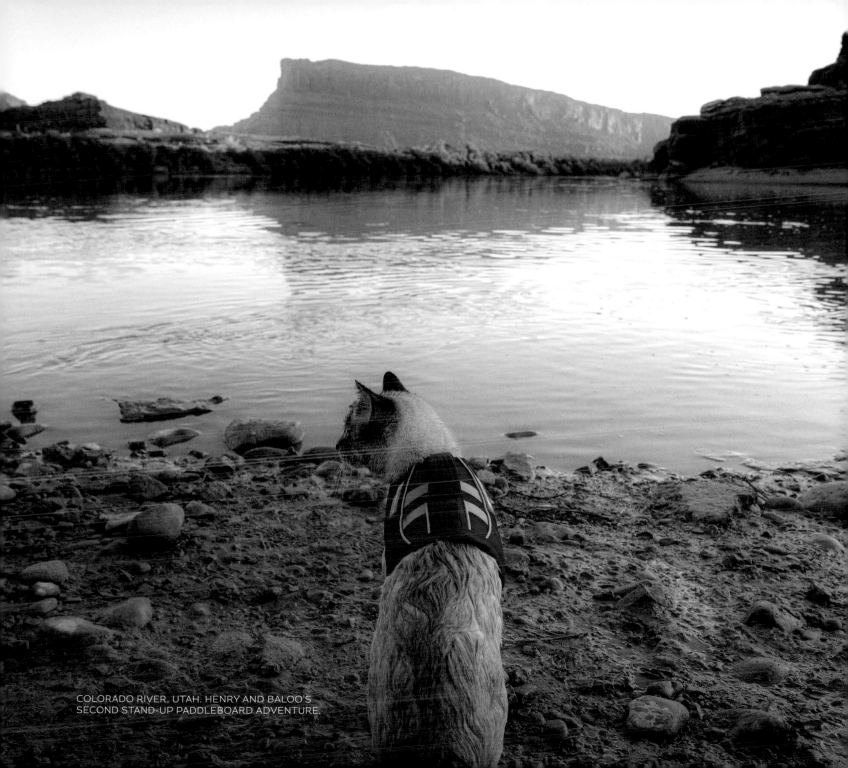

COLORADO RIVER, UTAH. HENRY AND BALOO'S
SECOND STAND-UP PADDLEBOARD ADVENTURE.

UNTIL ONE HAS

LOVED

AN ANIMAL,

A part of one's soul

REMAINS UNAWAKENED.

—ANATOLE FRANCE

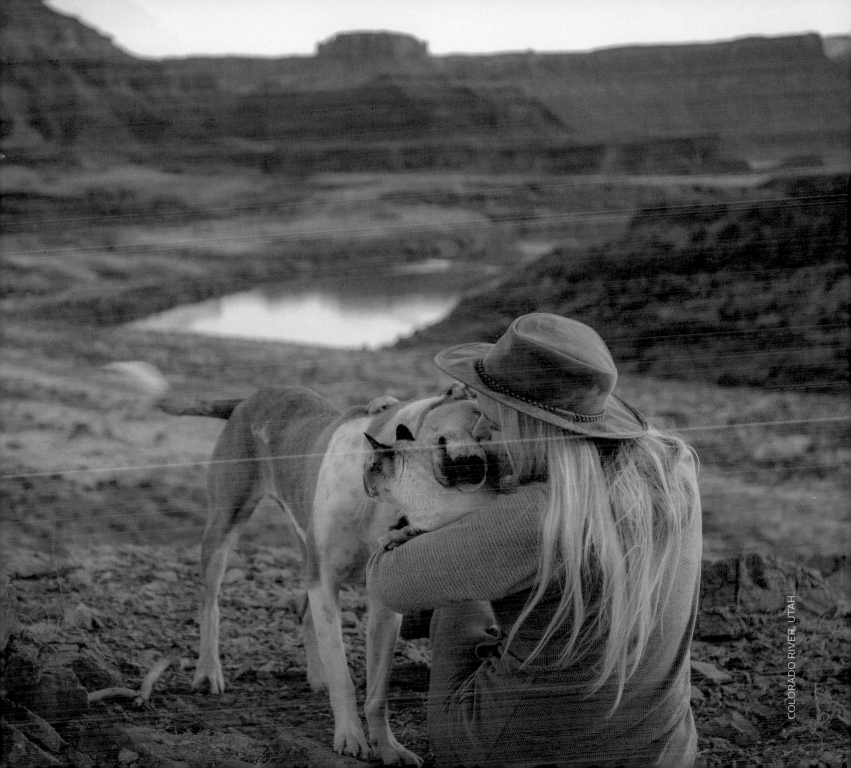

COLORADO RIVER, UTAH.

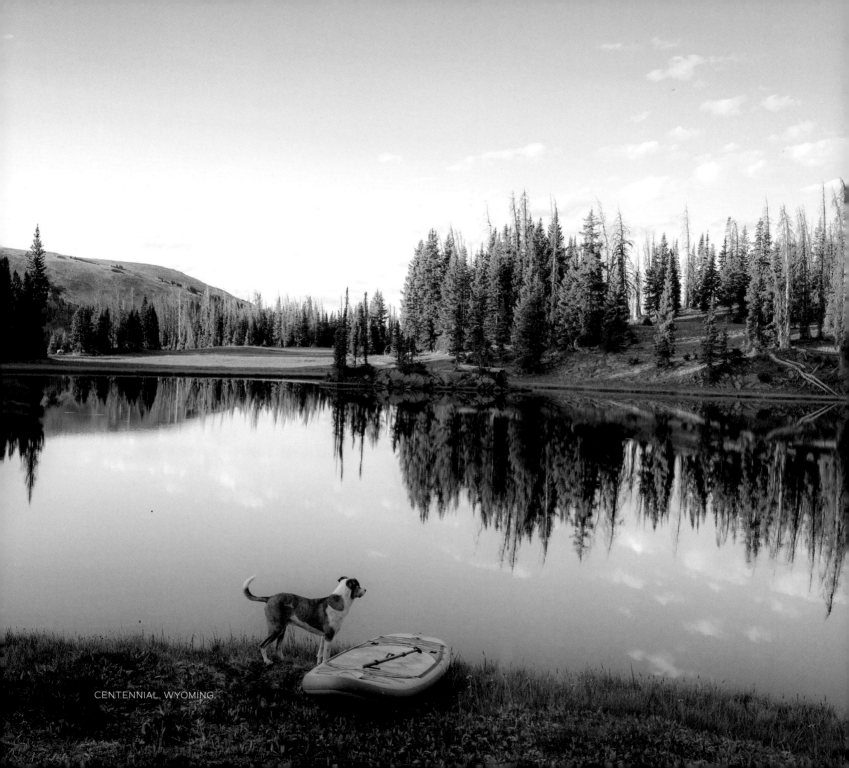

CENTENNIAL, WYOMING.

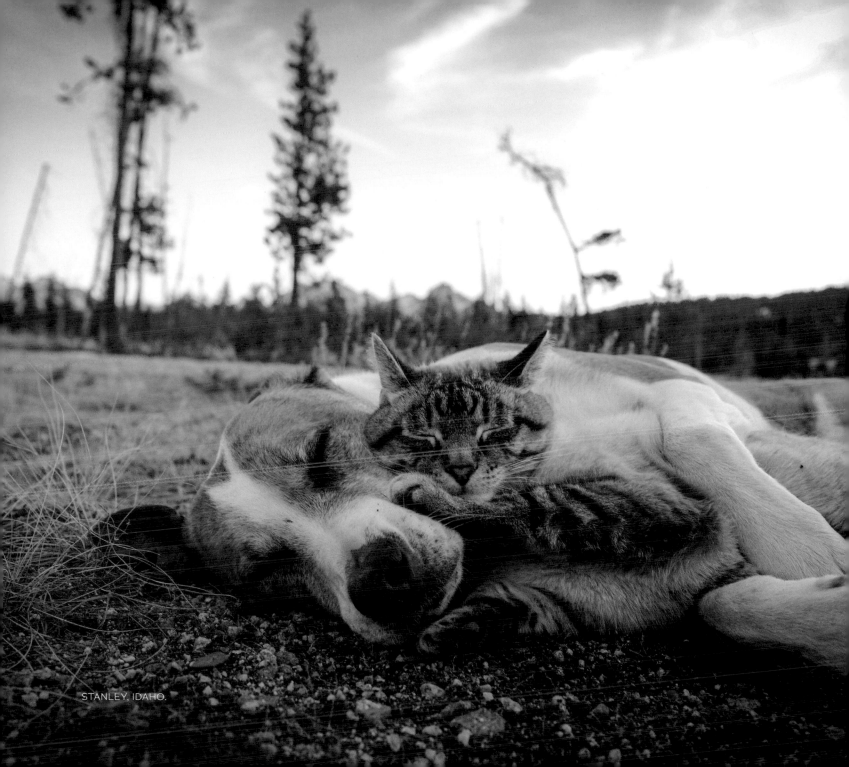

STANLEY, IDAHO.

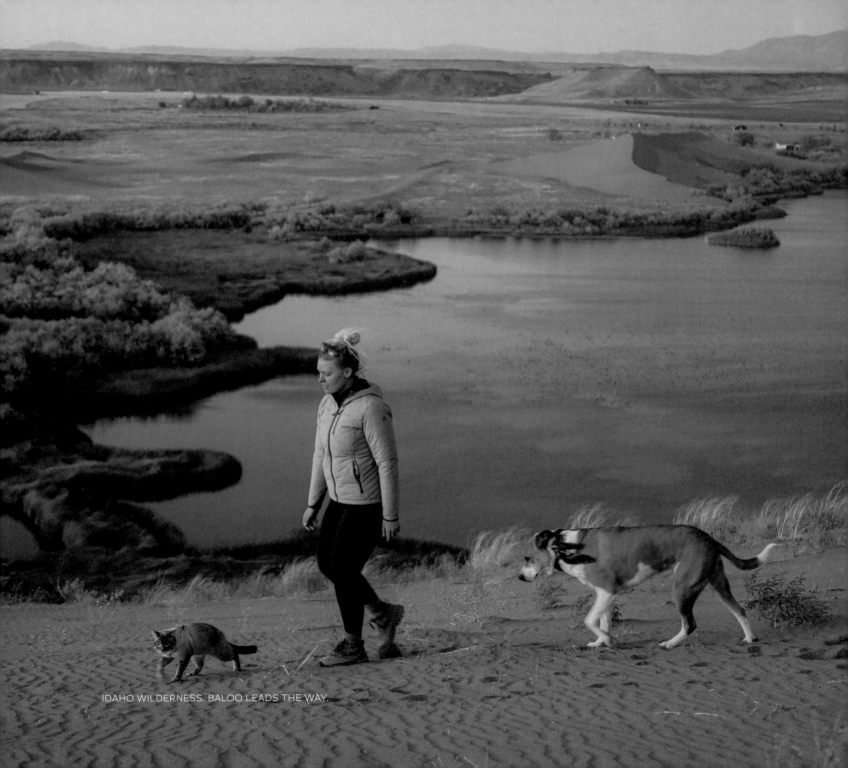

IDAHO WILDERNESS. BALOO LEADS THE WAY.

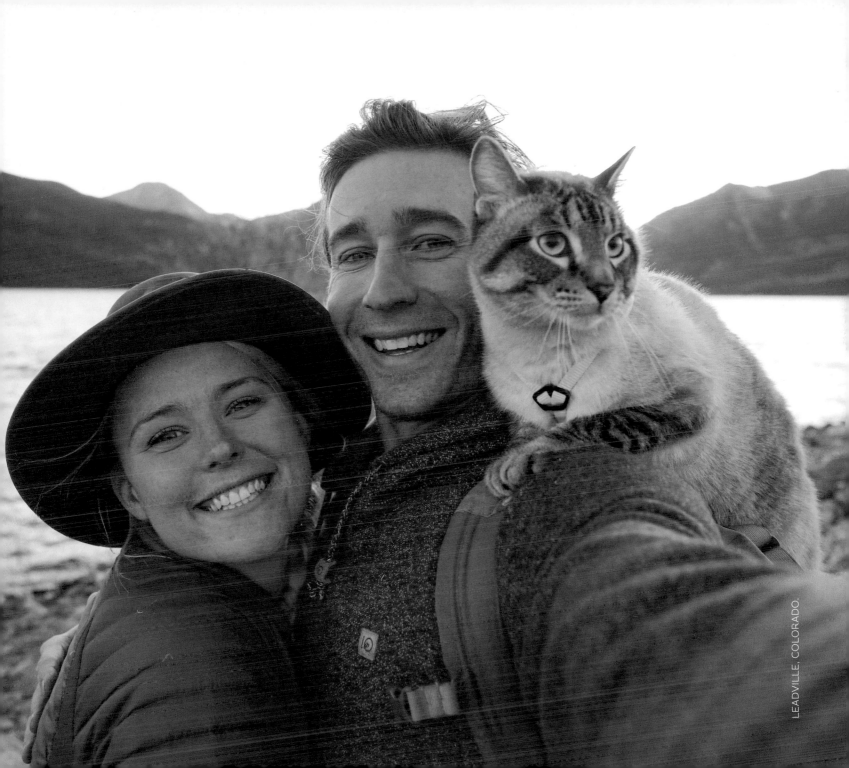

BRECKENRIDGE, COLORADO.

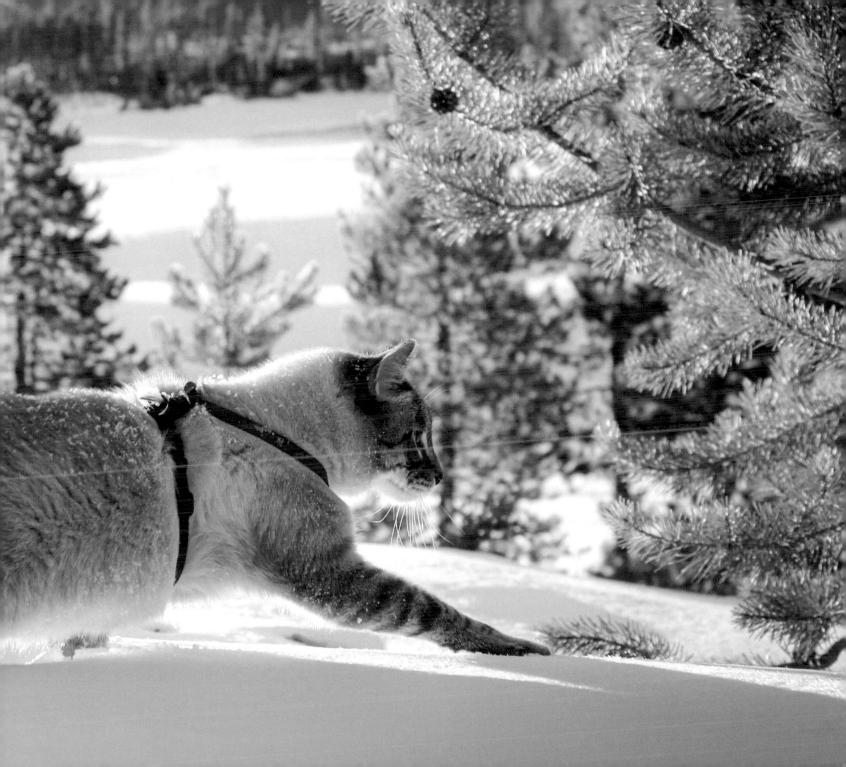

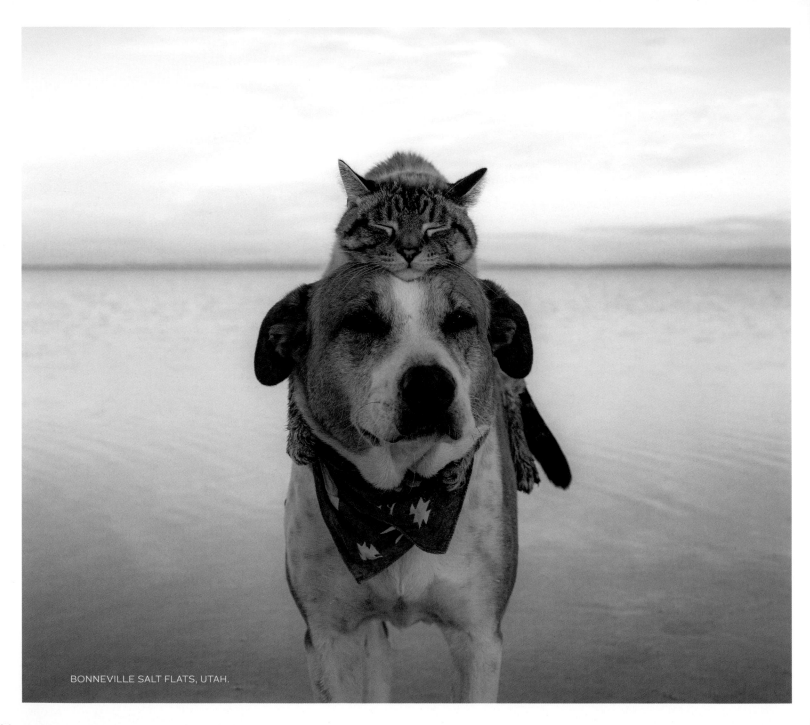

BONNEVILLE SALT FLATS, UTAH.

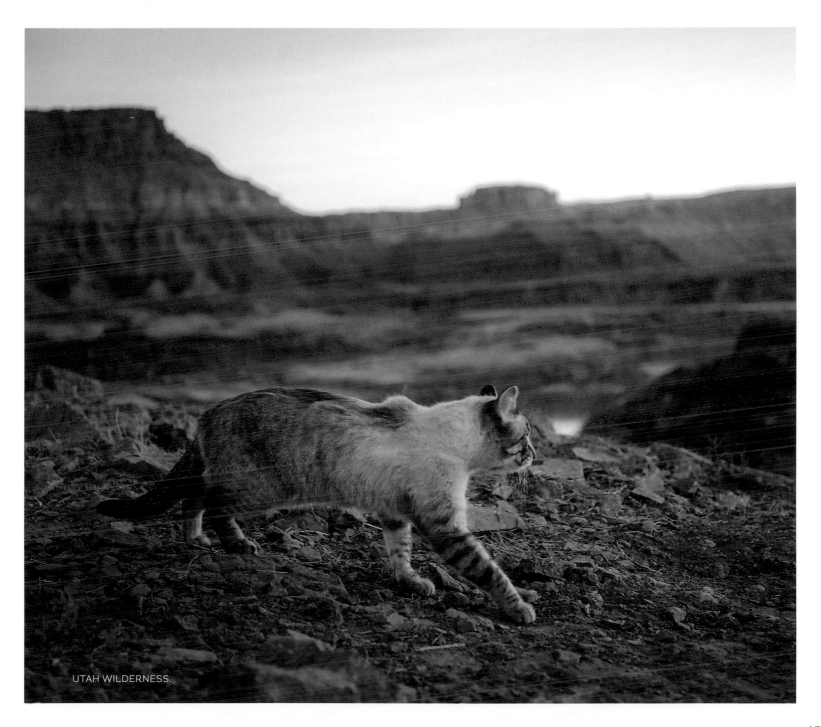

UTAH WILDERNESS.

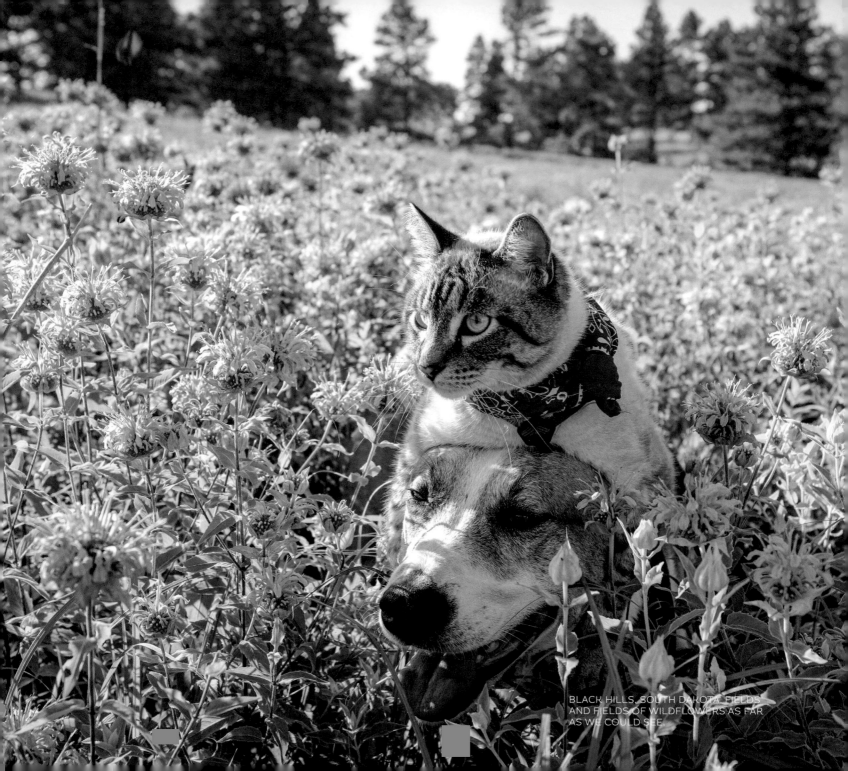

BLACK HILLS, SOUTH DAKOTA. FIELDS AND FIELDS OF WILDFLOWERS AS FAR AS WE COULD SEE.

FOR

MYSELF

I HOLD NO PREFERENCES

among flowers,

AS LONG AS THEY

ARE WILD.

—EDWARD ABBEY

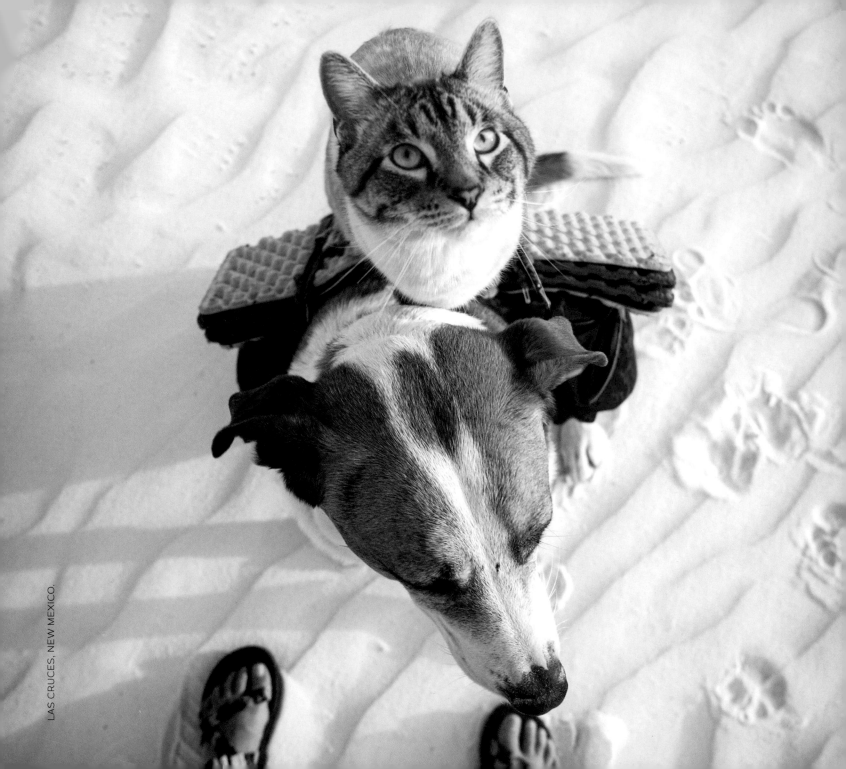

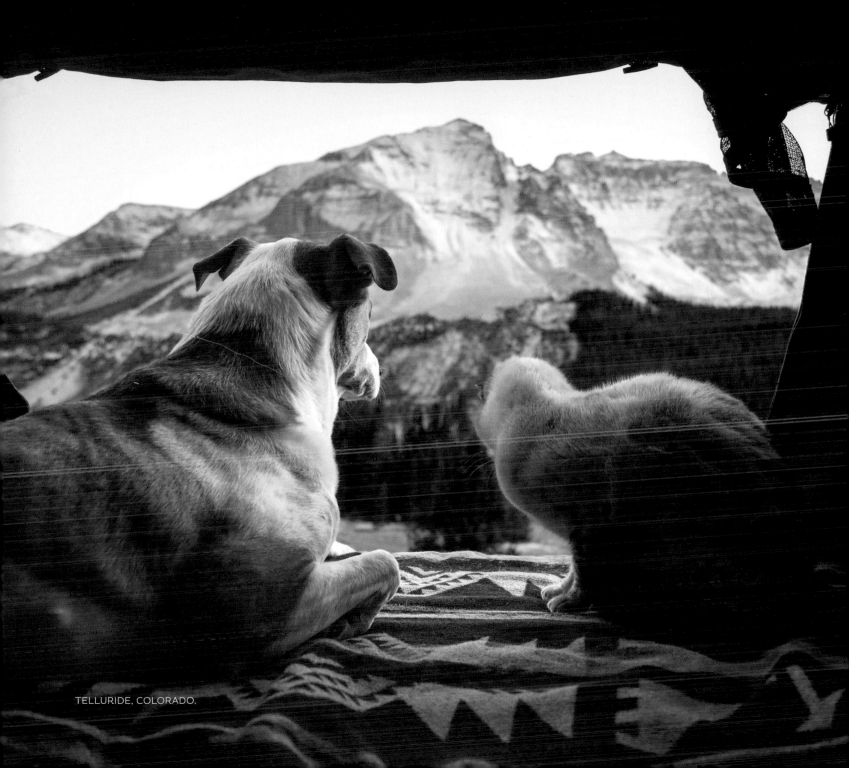

TELLURIDE, COLORADO.

FIRST

—— SNIFFS ——

INTRODUCING HENRY AND BALOO SCARED ME THE MOST. WILL THEY LIKE EACH OTHER? WILL THEY HATE EACH OTHER? WHAT IF HENRY LIKES BALOO, BUT BALOO HATES HENRY? BUT ALL OUR FEARS FADED AWAY AS THEY BECAME INSTANT FRIENDS, COMPLETELY SHOCKING US. I GUESS THERE WAS REALLY NOTHING TO WORRY ABOUT.

It was crazy watching their relationship develop in what felt like fast motion, taking only minutes for Baloo to begin crawling all over Henry. At first Henry didn't know what to think of this little, weird creature burrowing into his belly, but Baloo would not leave Henry alone—not for one second. It didn't matter if Henry ignored him or moved from the couch to his bed, B would soon be there at his side.

We think Baloo decided that Henry was his mom or dad (even if Henry looked a little funny), because he was so desperately looking for a parent. His cat mom abandoned the litter soon after he was born, so Baloo never had anyone to look up to or learn from. B's search was over when he met confident, big but nurturing Henry. Why spend one more minute alone when he could be cuddling with his long-lost parent? Andre and I adopted Baloo, but little did Henry know he was adopting a kitten too!

Even though they were incredibly close already, and getting closer every day, we wanted to strengthen that bond even more by having them do lots of things together. We fed them treats together, took them on car rides together, fed them breakfast and dinner together, went to the park together, and soon went to the woods and adventured together. Not only did this show them that they enjoy the same things, it created a pack (family) mentality. I strongly believe that this is why Baloo doesn't run away on the trail. He doesn't want to leave his pack because a pack sticks together.

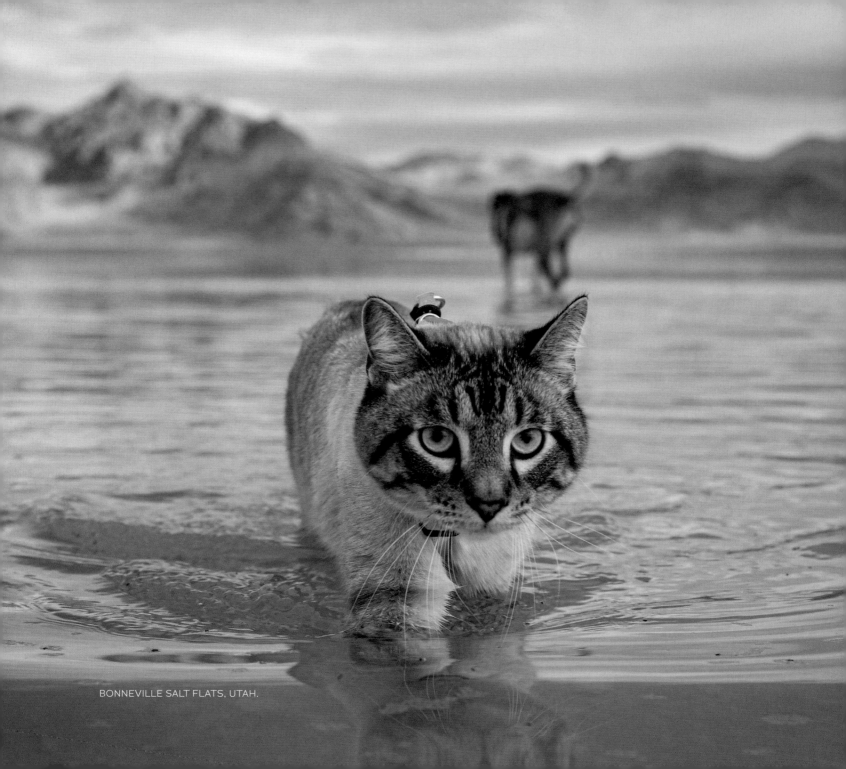

BONNEVILLE SALT FLATS, UTAH.

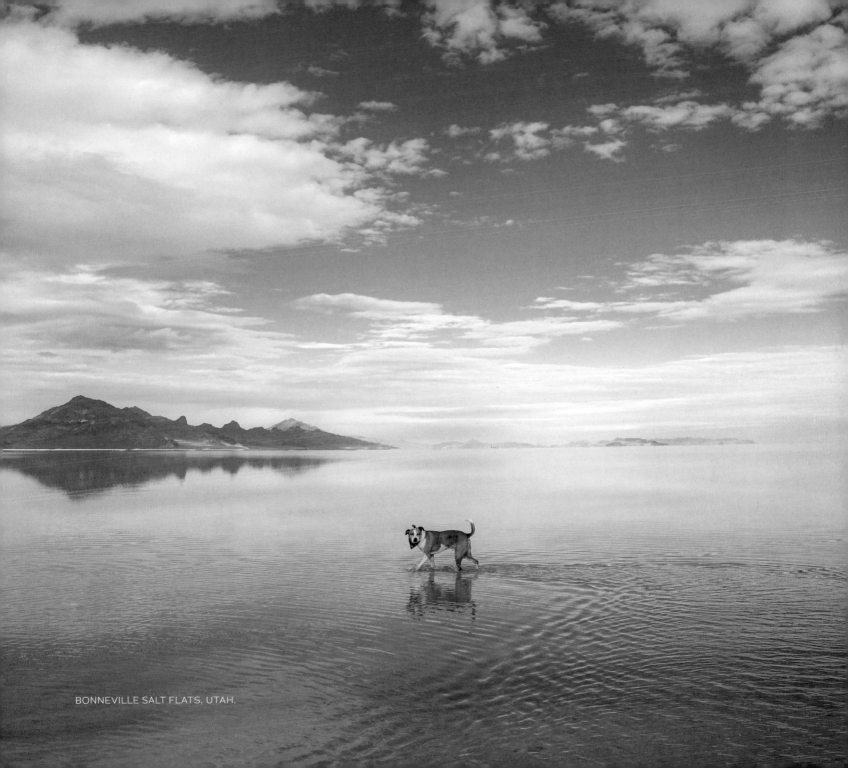

BONNEVILLE SALT FLATS, UTAH.

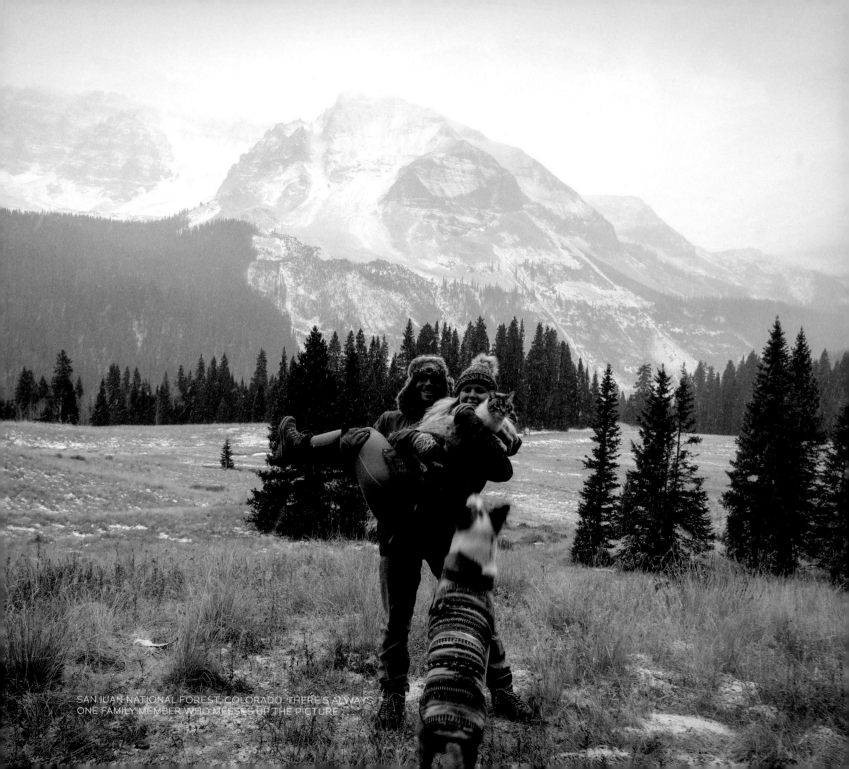

SAN JUAN NATIONAL FOREST, COLORADO. THERE'S ALWAYS
ONE FAMILY MEMBER WHO MESSES UP THE PICTURE.

OHANA MEANS

——

FAMILY.

FAMILY MEANS

NOBODY GETS LEFT BEHIND

OR forgotten.

——

--LILO AND STITCH

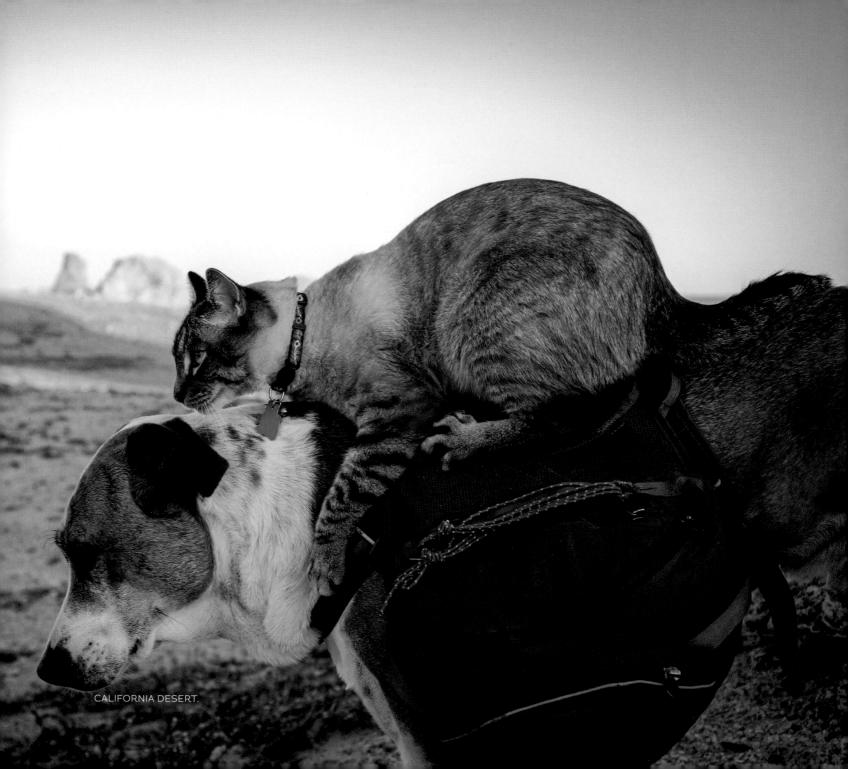

CALIFORNIA DESERT.

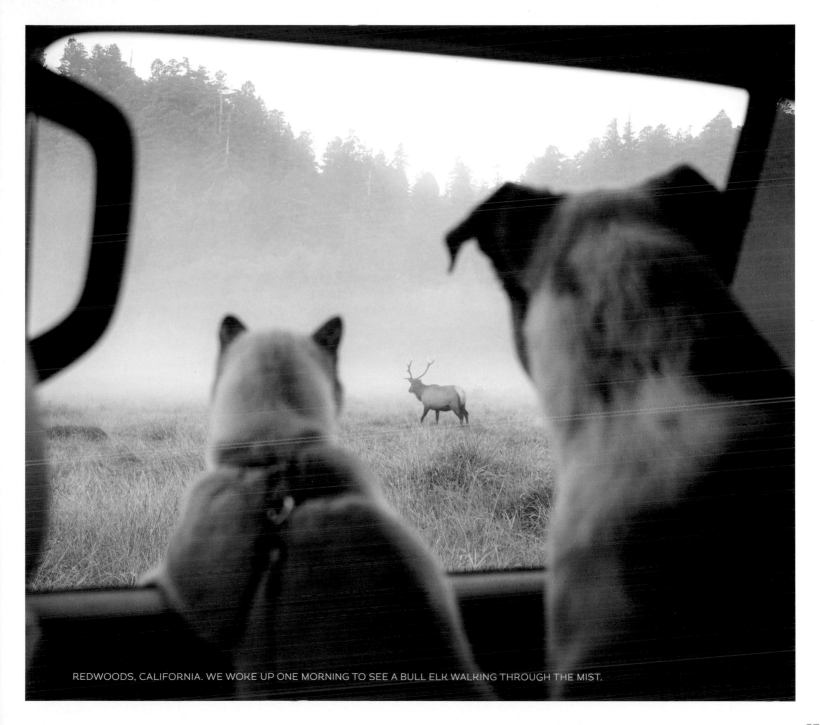

REDWOODS, CALIFORNIA. WE WOKE UP ONE MORNING TO SEE A BULL ELK WALKING THROUGH THE MIST.

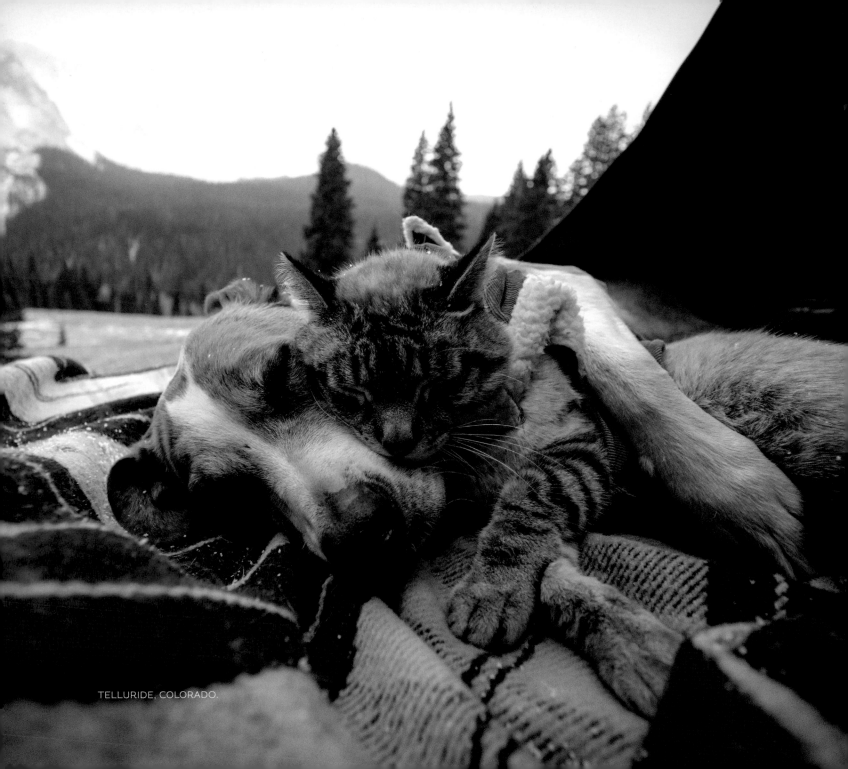

TELLURIDE, COLORADO.

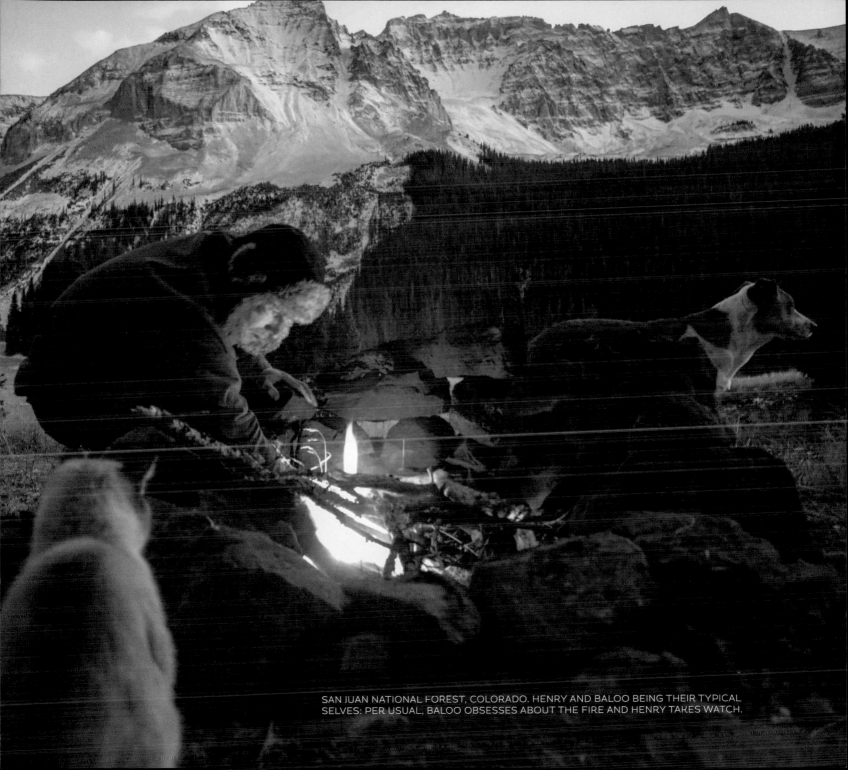

SAN JUAN NATIONAL FOREST, COLORADO. HENRY AND BALOO BEING THEIR TYPICAL SELVES: PER USUAL, BALOO OBSESSES ABOUT THE FIRE AND HENRY TAKES WATCH.

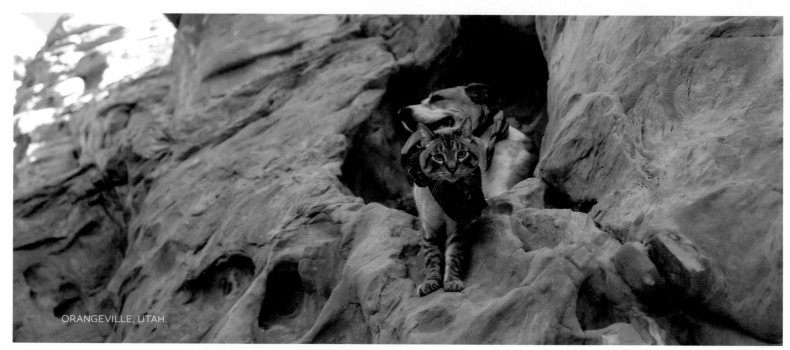

ORANGEVILLE, UTAH.

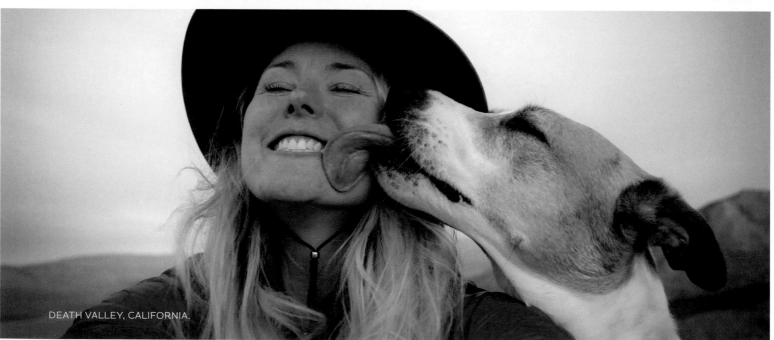

DEATH VALLEY, CALIFORNIA.

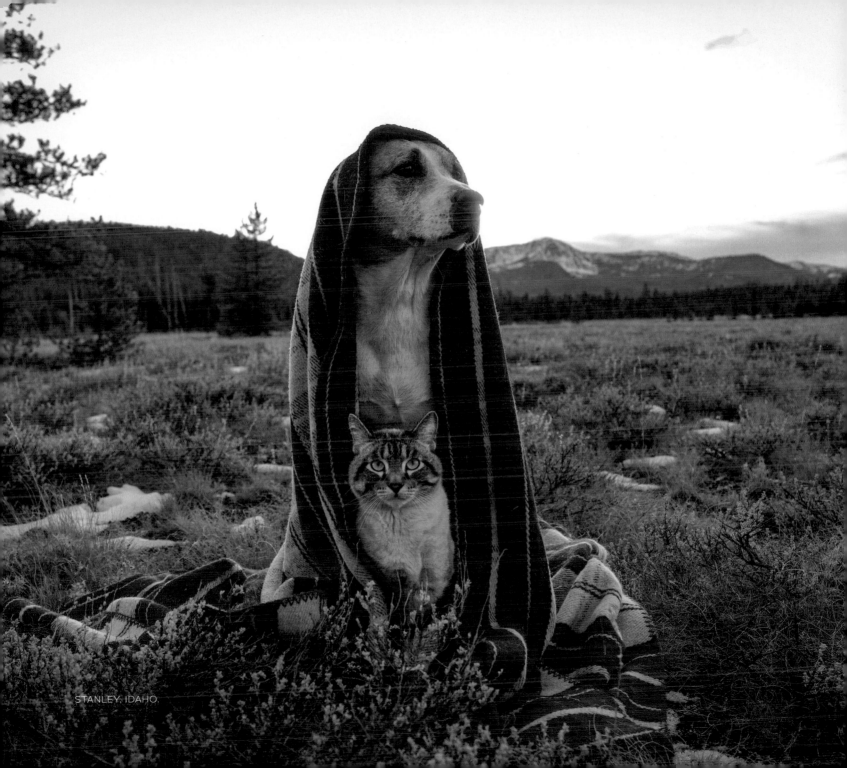

STANLEY, IDAHO.

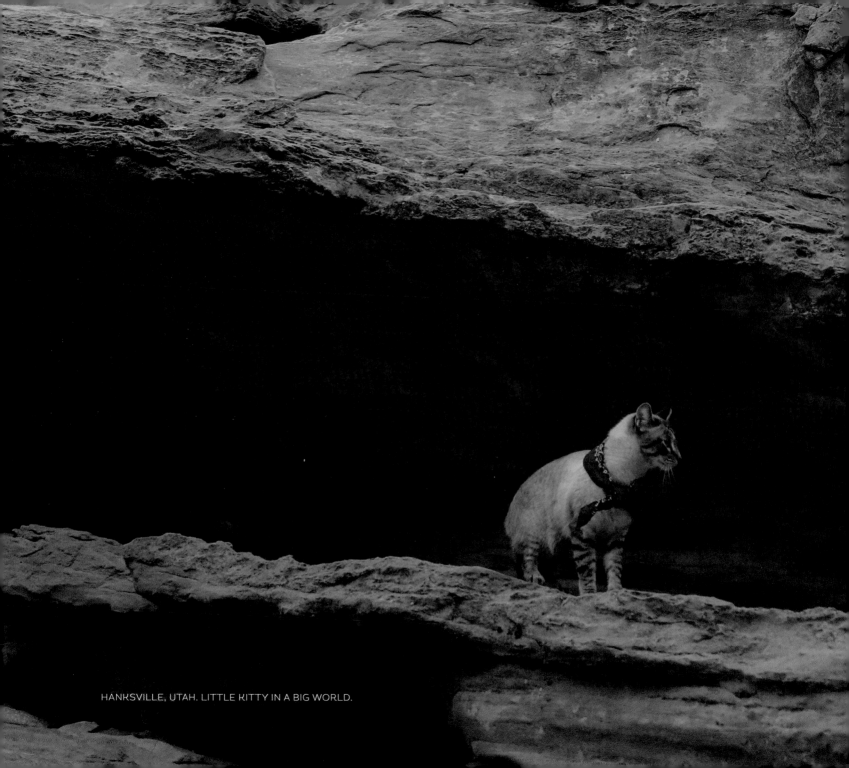

HANKSVILLE, UTAH. LITTLE KITTY IN A BIG WORLD.

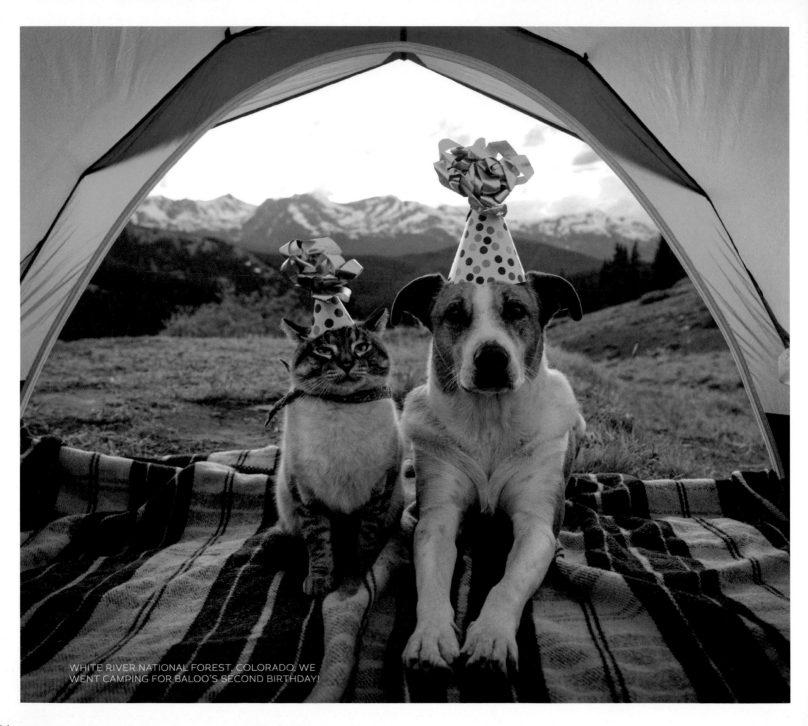

WHITE RIVER NATIONAL FOREST, COLORADO. WE
WENT CAMPING FOR BALOO'S SECOND BIRTHDAY!

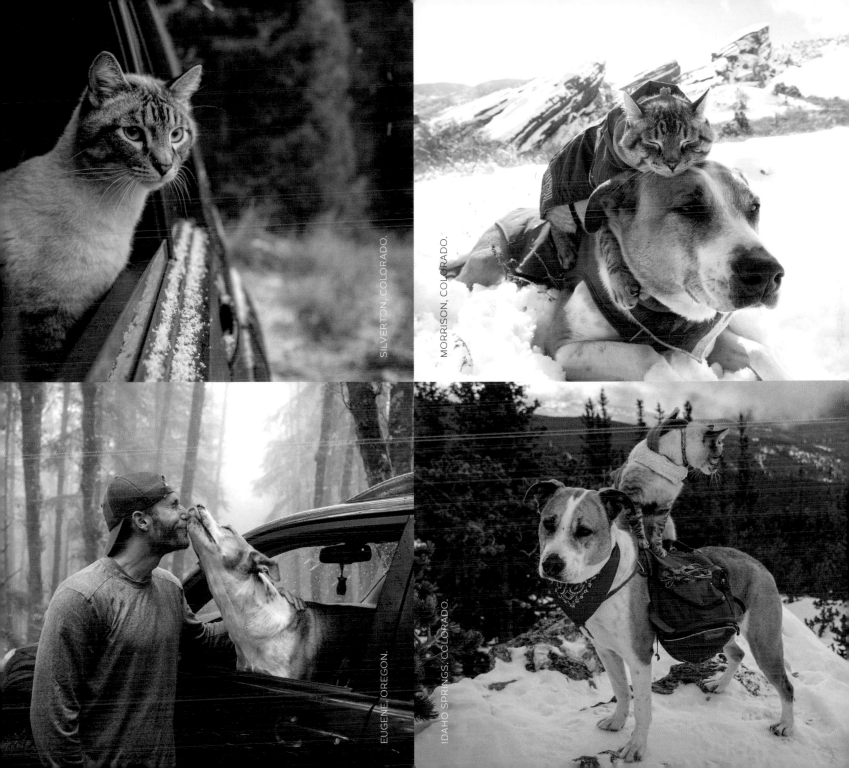

SILVERTON, COLORADO.

MORRISON, COLORADO.

EUGENE, OREGON.

IDAHO SPRINGS, COLORADO.

COMPASSION

—

FOR ANIMALS

IS intimately associated

WITH GOODNESS

OF CHARACTER.

—

—ARTHUR SCHOPENHAUER

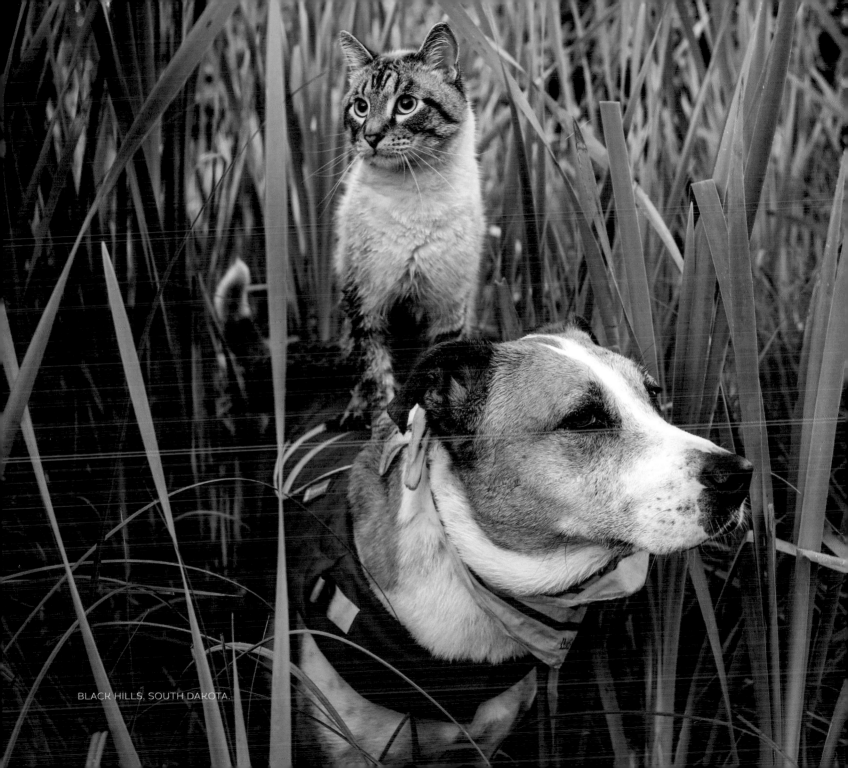

BLACK HILLS, SOUTH DAKOTA.

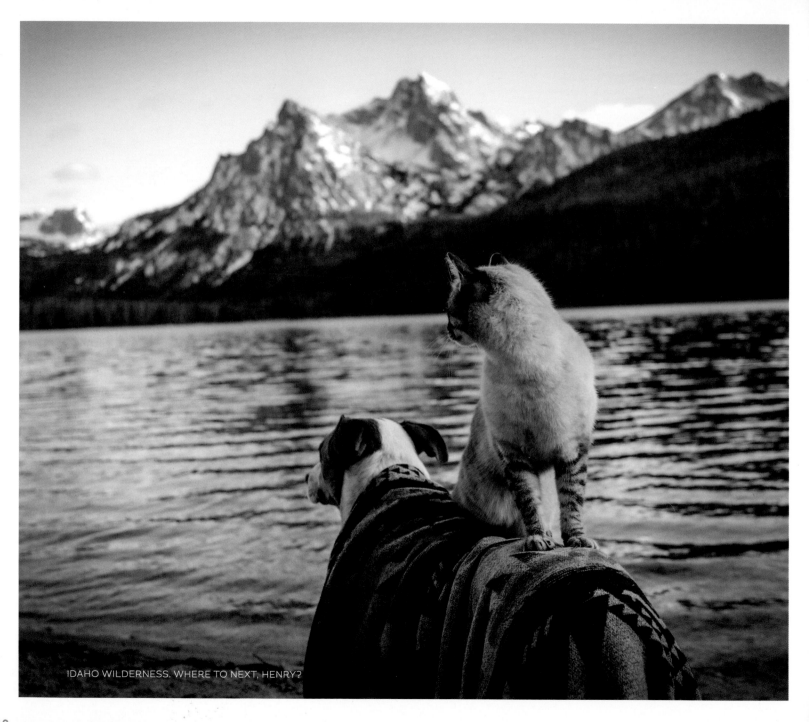

IDAHO WILDERNESS. WHERE TO NEXT, HENRY?

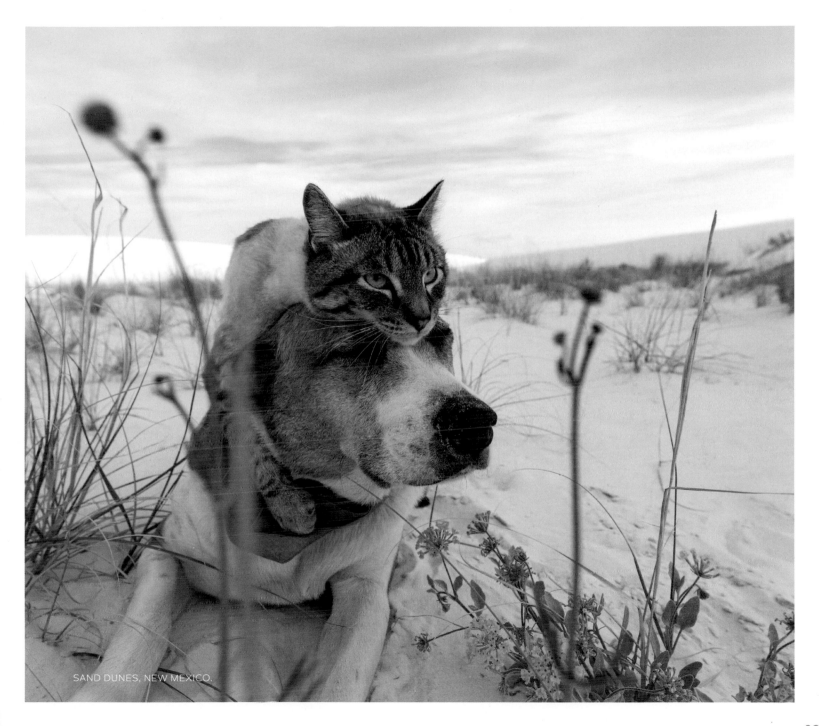

SAND DUNES, NEW MEXICO.

SAND DUNES, NEW MEXICO.

WHAT GOOD
is the
WARMTH
OF SUMMER, WITHOUT THE COLD
 winter to give it
SWEETNESS.

———

—JOHN STEINBECK

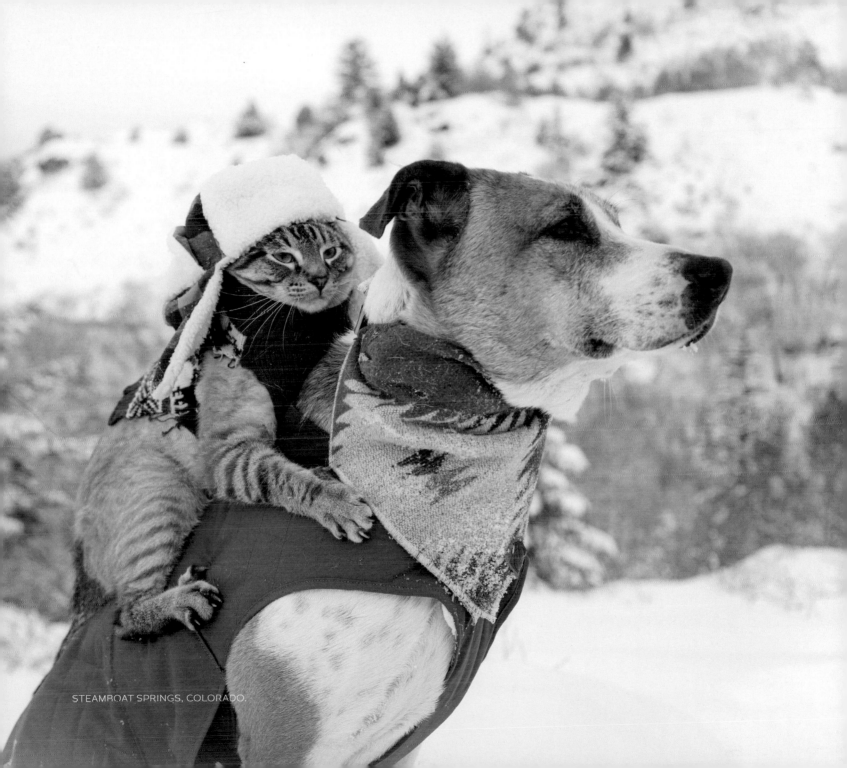

STEAMBOAT SPRINGS, COLORADO.

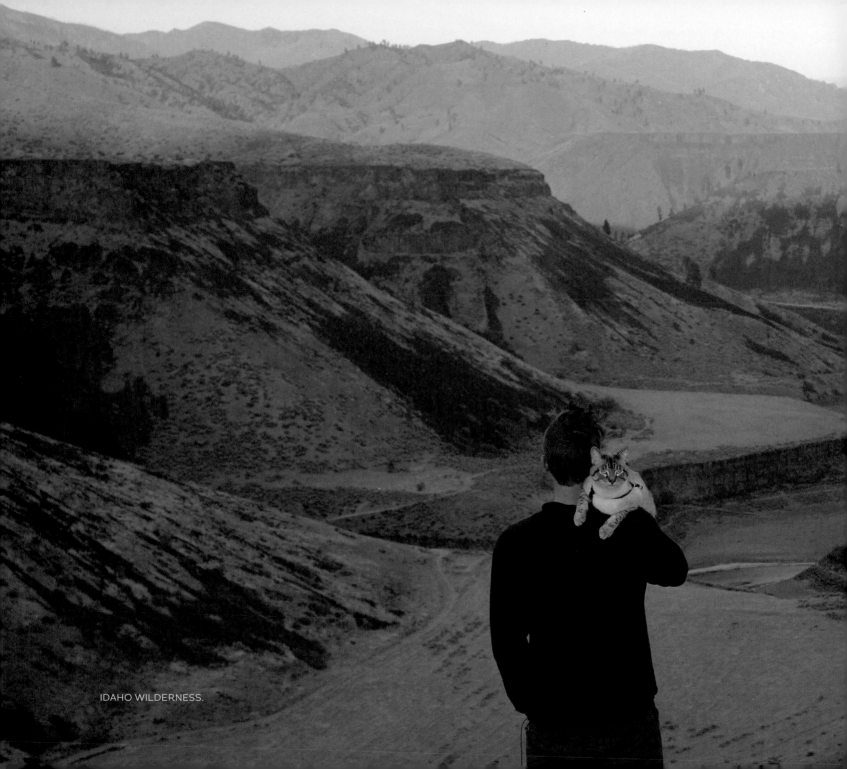

IDAHO WILDERNESS.

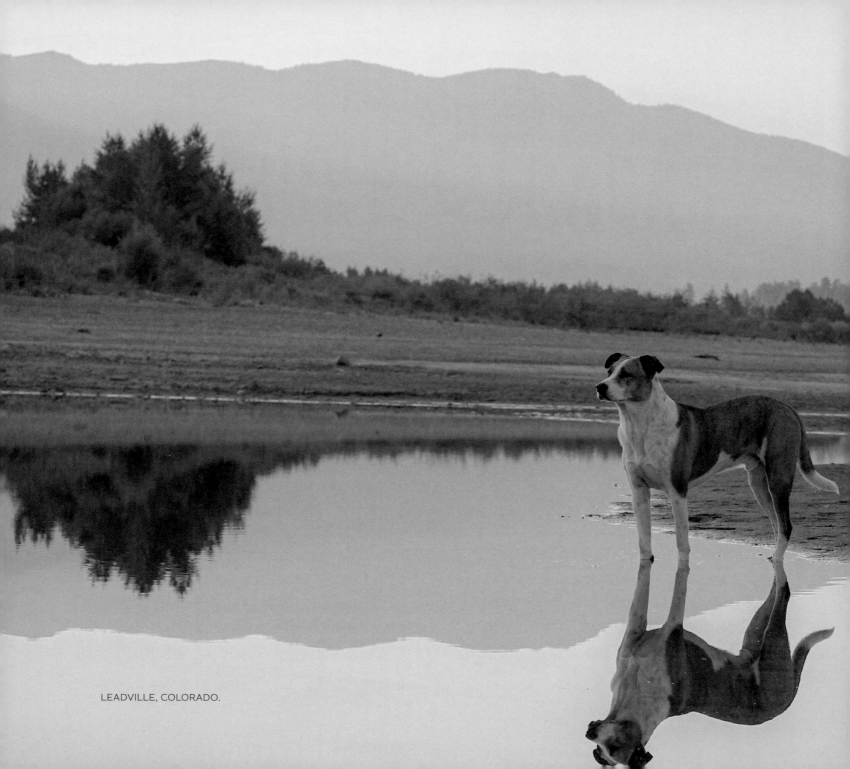

LEADVILLE, COLORADO.

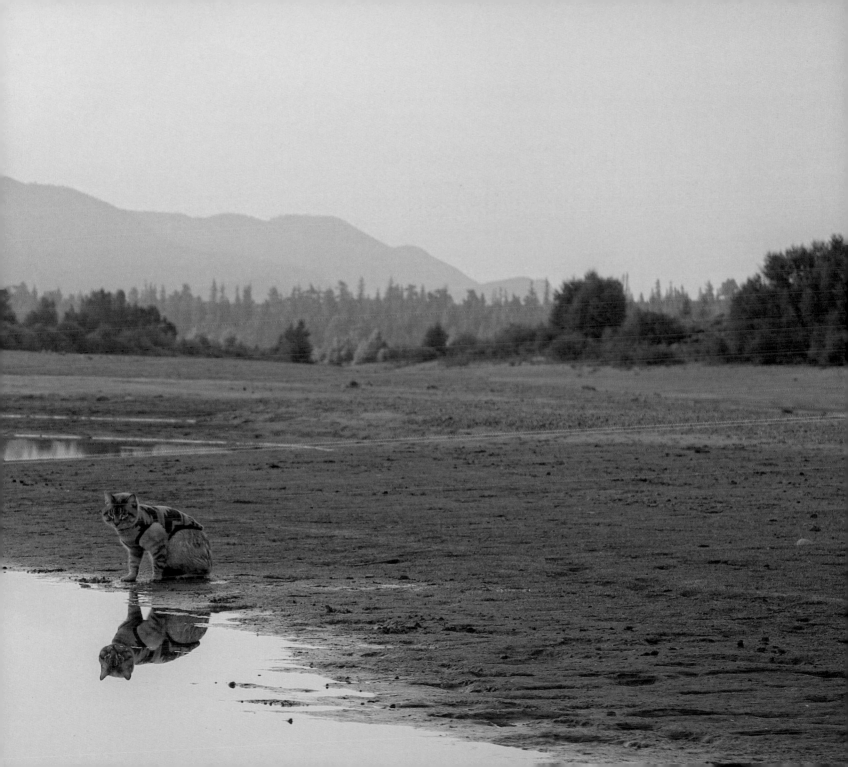

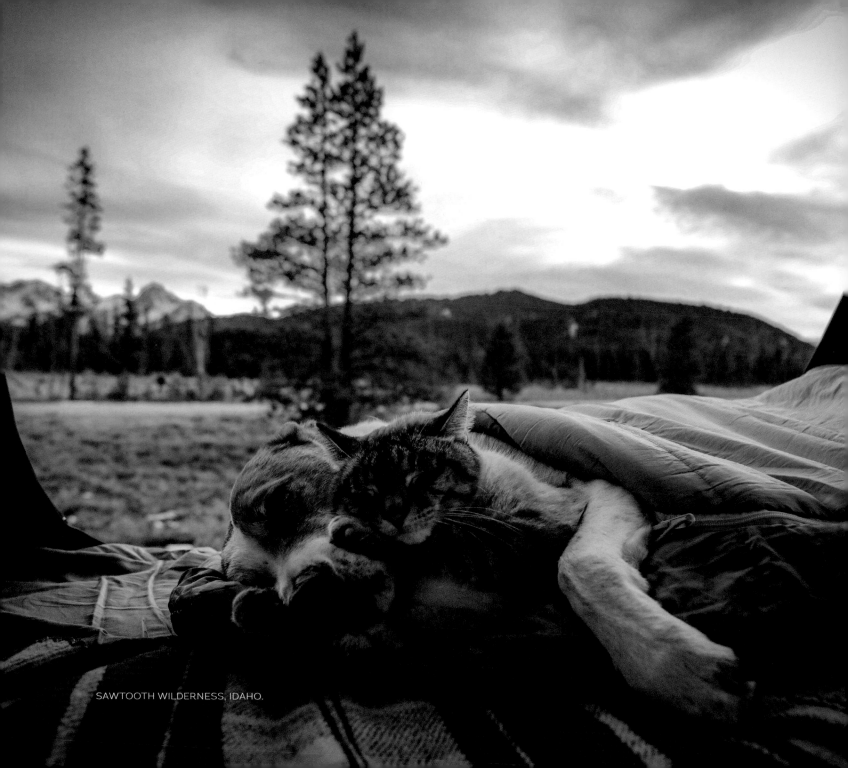

SAWTOOTH WILDERNESS, IDAHO.

ALL GOOD THINGS ARE

WILD
& free.

—HENRY DAVID THOREAU

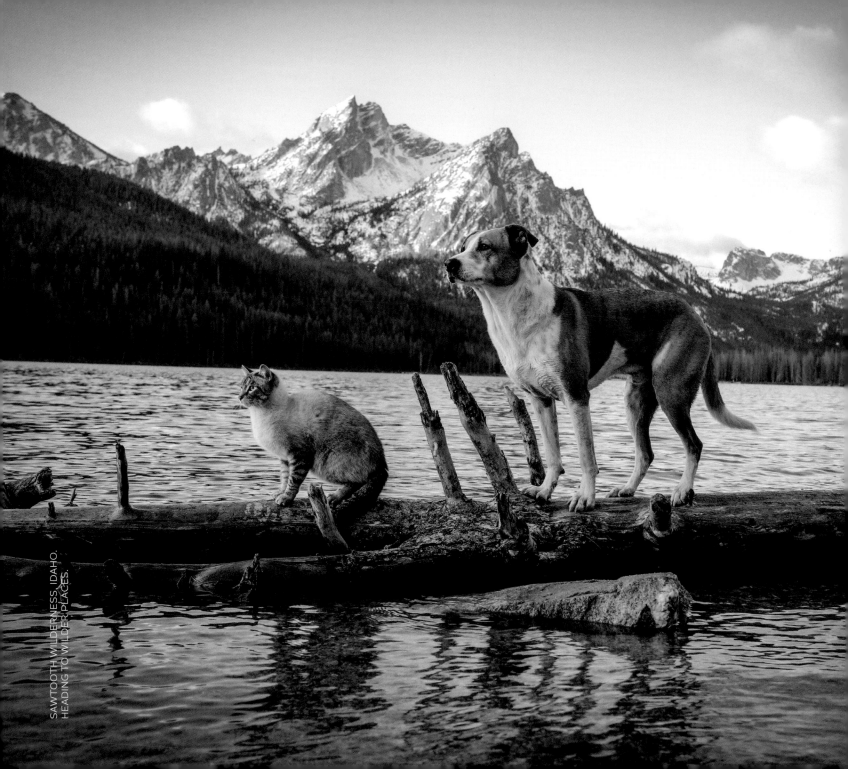

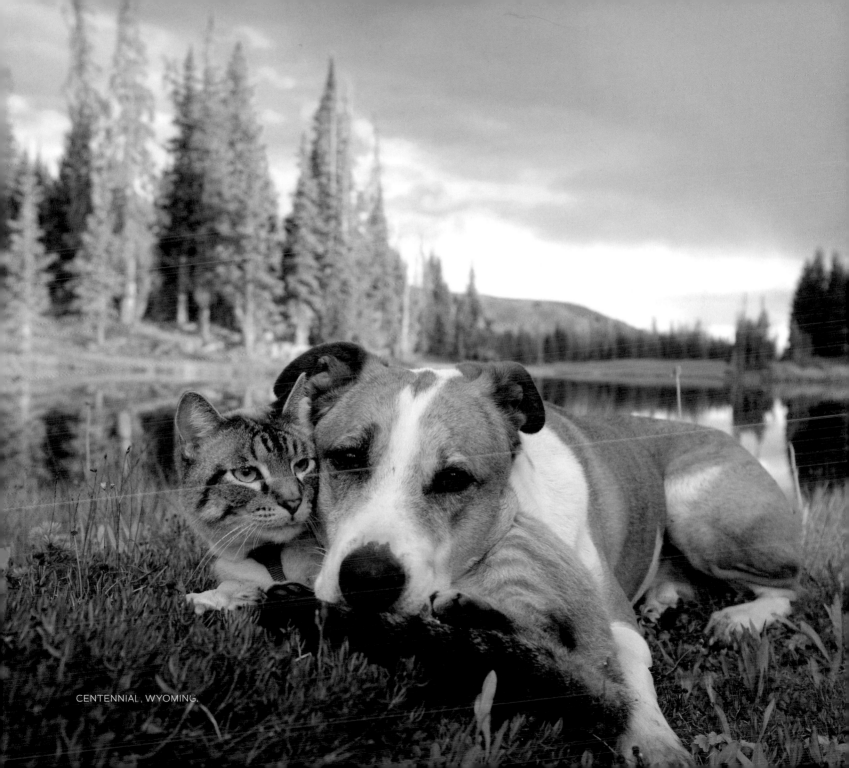

CENTENNIAL, WYOMING.

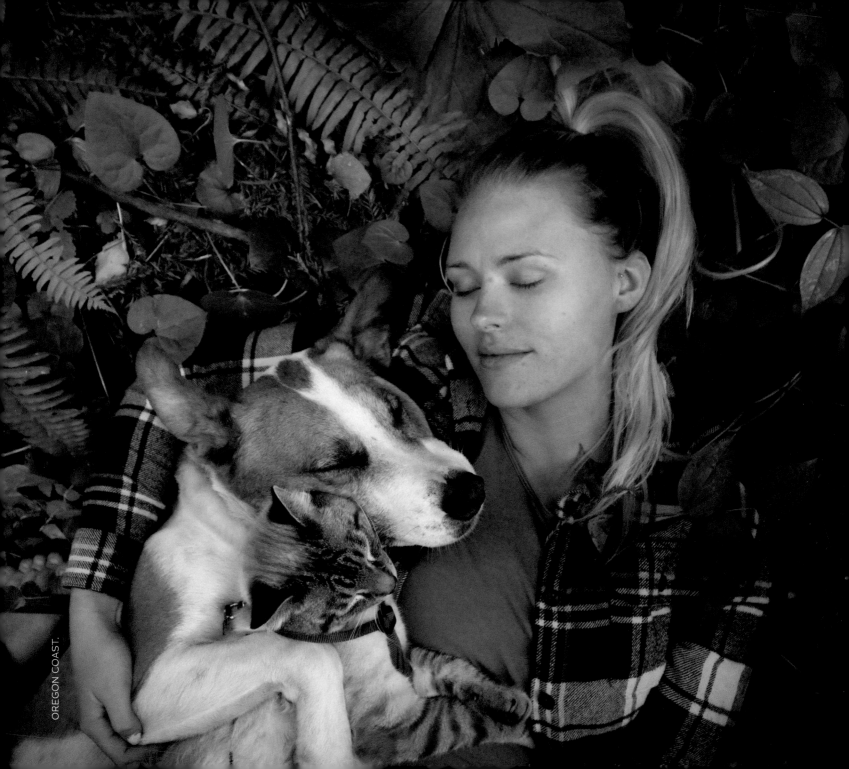

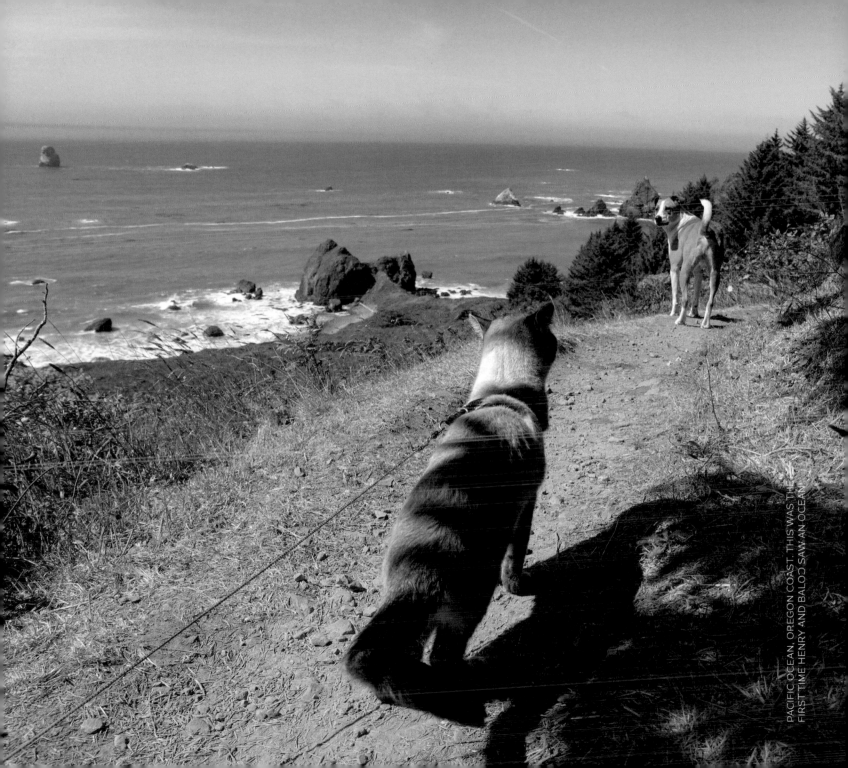

PACIFIC OCEAN. OREGON COAST. THIS WAS THE
FIRST TIME HENRY AND BALOO SAW AN OCEAN.

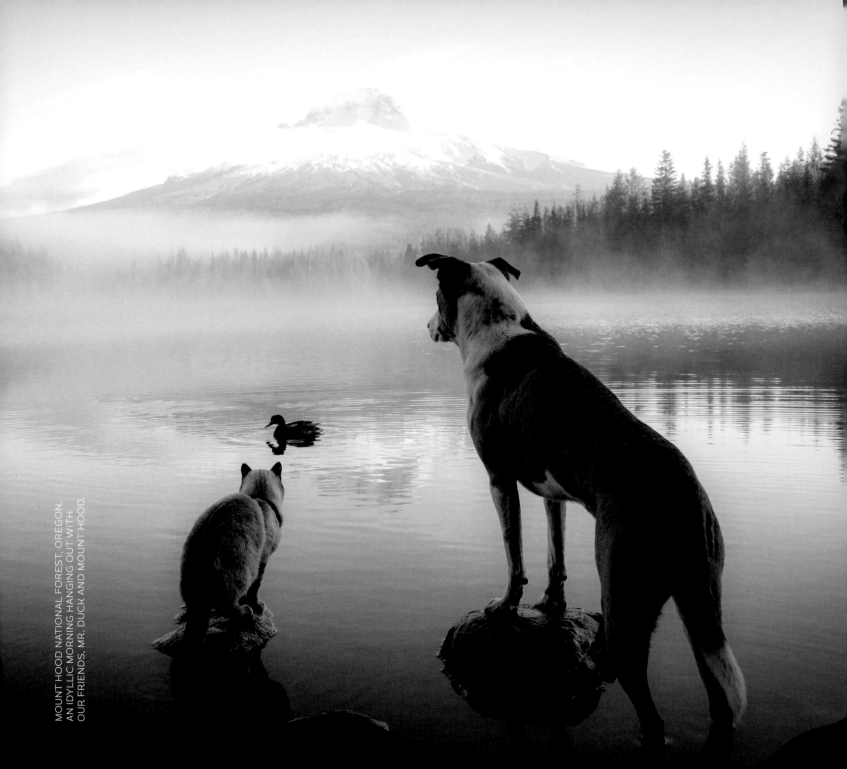

MOUNT HOOD NATIONAL FOREST, OREGON.
AN IDYLLIC MORNING HANGING OUT WITH
OUR FRIENDS, MR. DUCK AND MOUNT HOOD.

ALL WE HAVE,

it seems to me, is the

BEAUTY

OF ART AND NATURE AND LIFE,

& the love which that

BEAUTY INSPIRES.

———

—EDWARD ABBEY

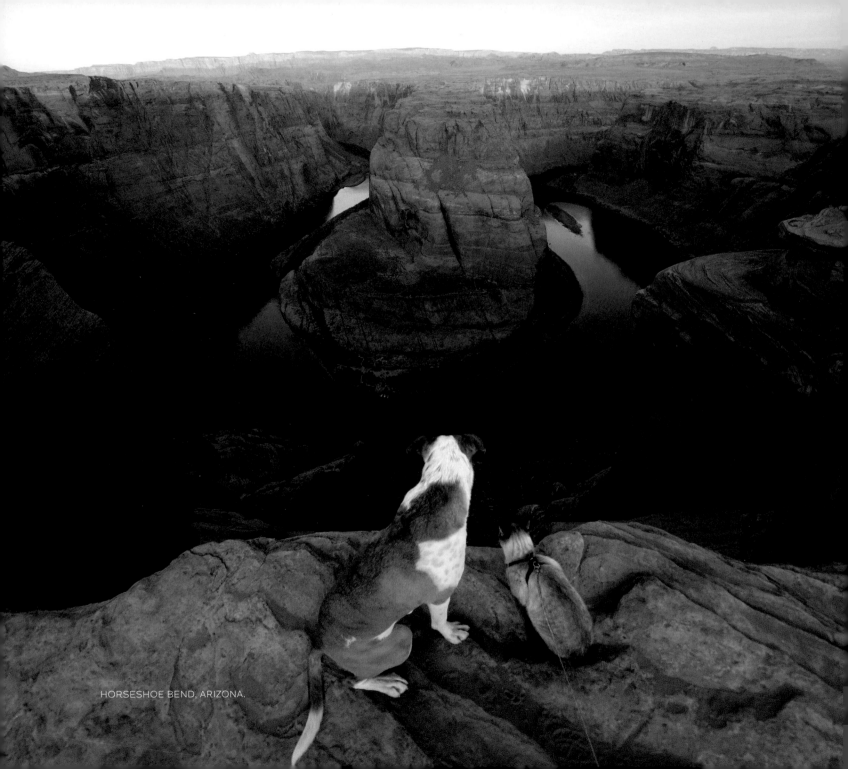

HORSESHOE BEND, ARIZONA.

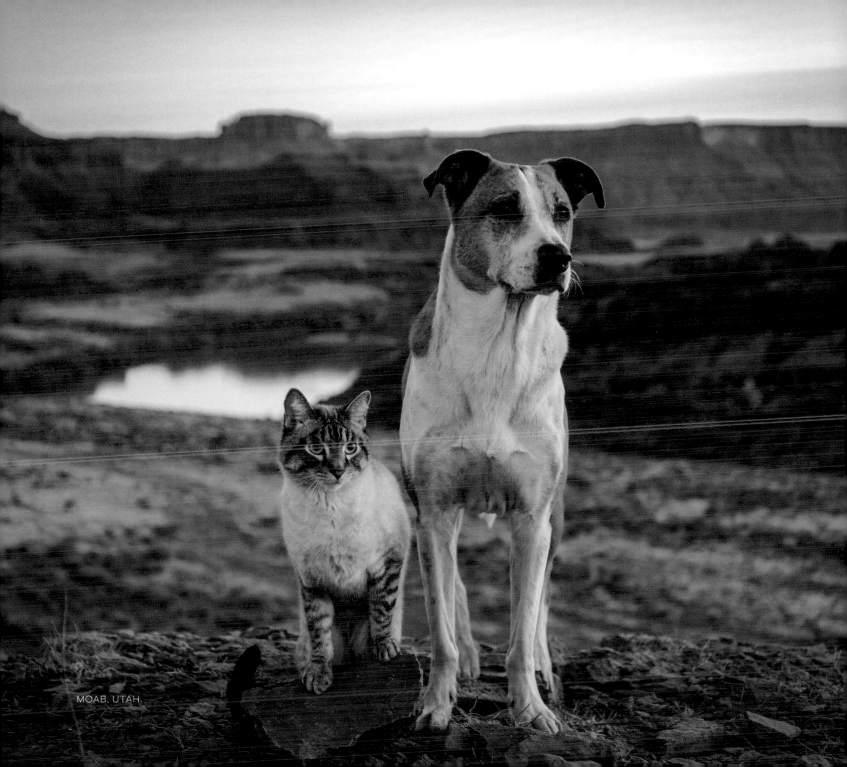

MOAB, UTAH.

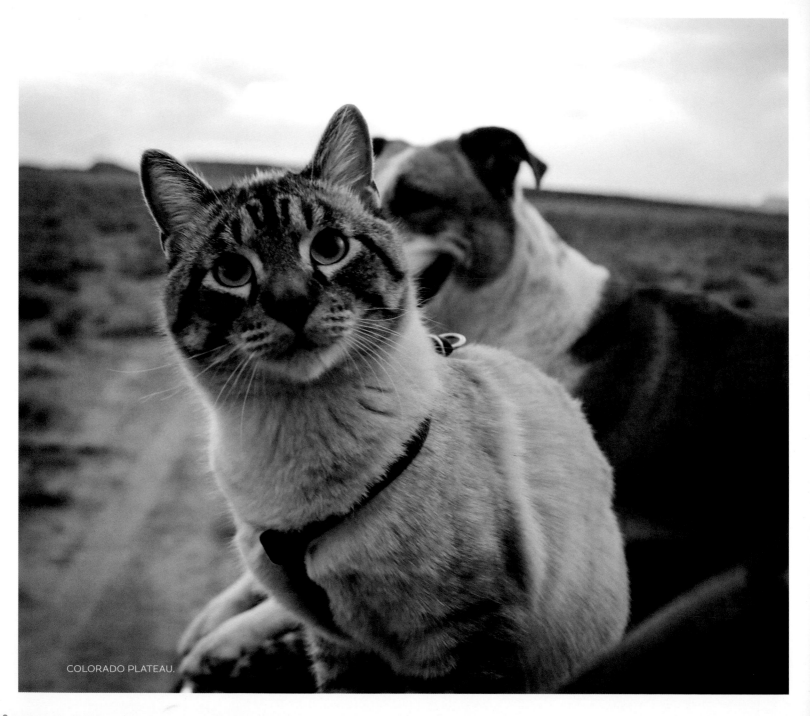

COLORADO PLATEAU.

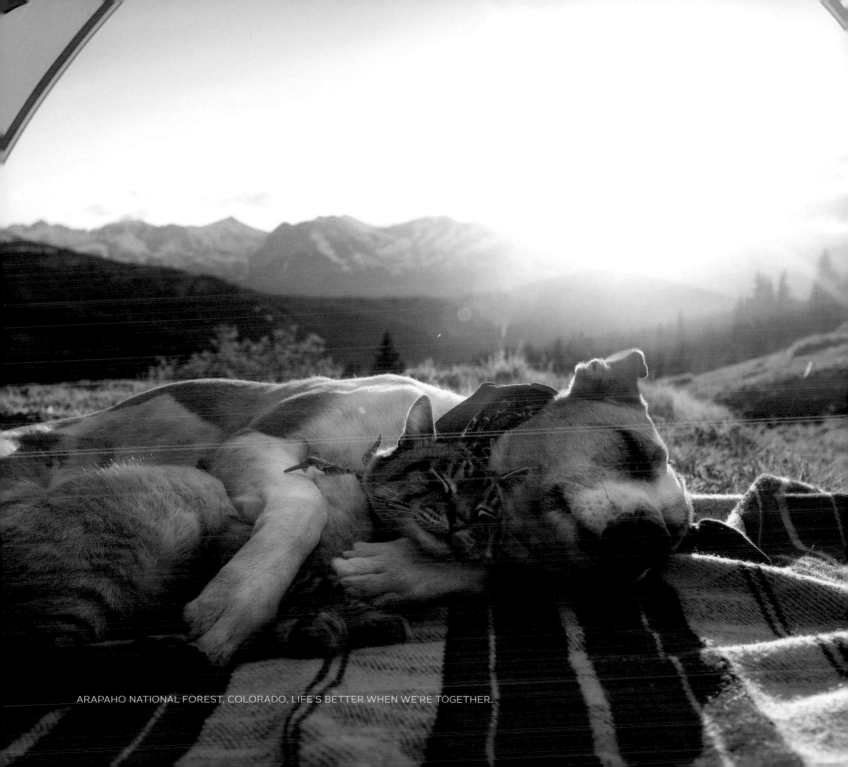

ARAPAHO NATIONAL FOREST, COLORADO. LIFE'S BETTER WHEN WE'RE TOGETHER.

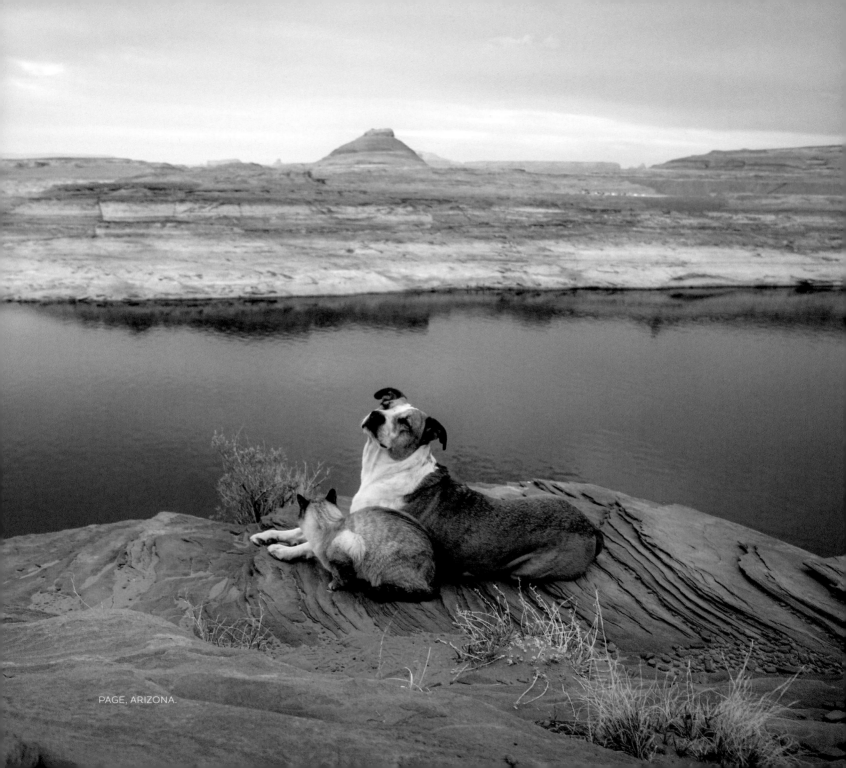

PAGE, ARIZONA.

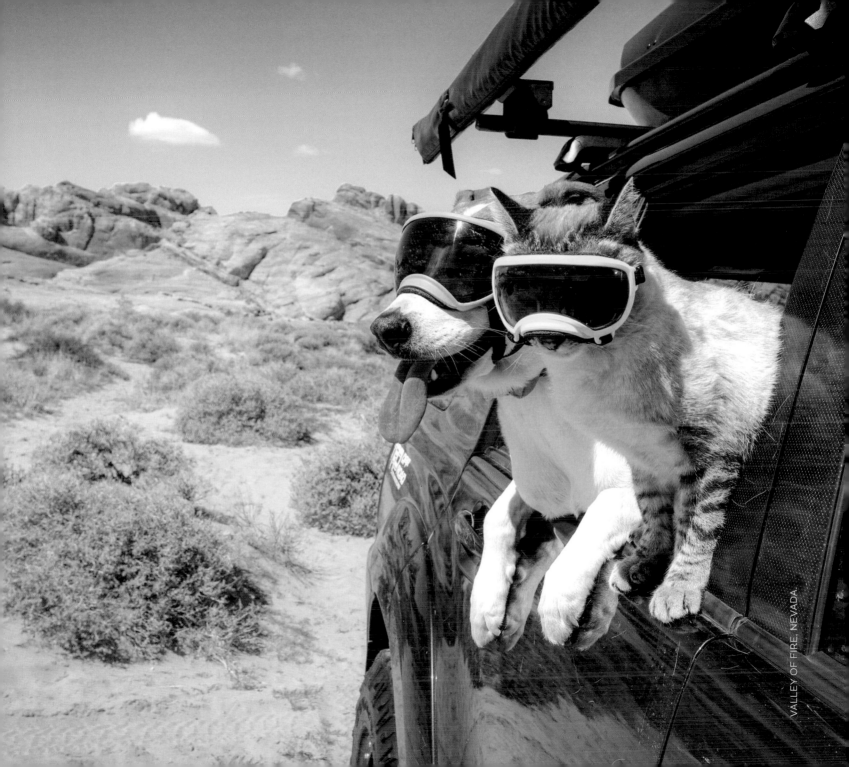

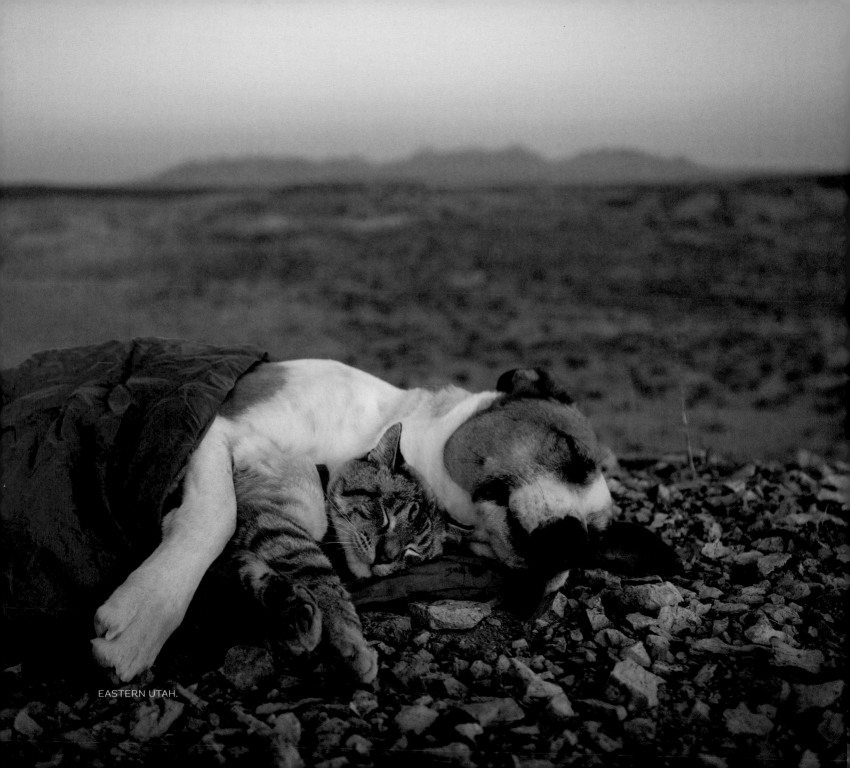

EASTERN UTAH.

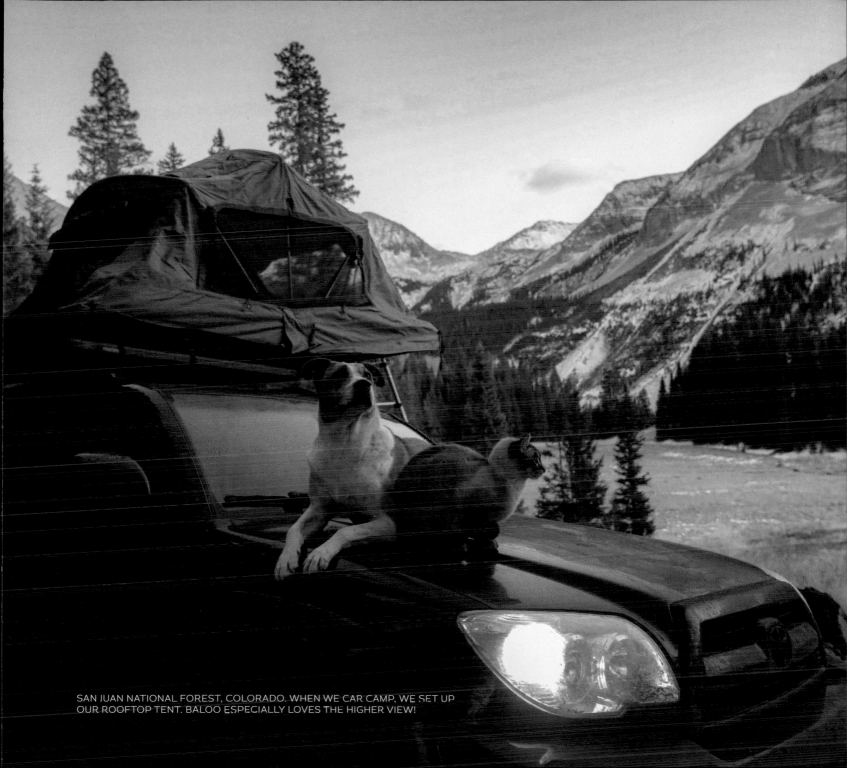

SAN JUAN NATIONAL FOREST, COLORADO. WHEN WE CAR CAMP, WE SET UP OUR ROOFTOP TENT. BALOO ESPECIALLY LOVES THE HIGHER VIEW!

FIRST

— CAMP —

SEEING BALOO HAVE THE GREATEST TIME EXPLORING WITH HENRY, I DECIDED TO TAKE HIM ON OUR CAMPING TRIP TO TELLURIDE, COLORADO, AND I'M SO THANKFUL I DID. BEFORE WE LEFT, HENRY LOVED AND CARED ABOUT BALOO, BUT SOMETHING WAS MISSING FOR HIM. HIS TRUE LOVE IS THE OUTDOORS; HE ALWAYS COMES ALIVE AS SOON AS HE GETS A WHIFF OF FRESH AIR FROM A WILDER PLACE. I THINK BECAUSE BALOO HADN'T YET BEEN A PART OF "HENRY'S WORLD," HENRY FELT HE DIDN'T HAVE THE FRIEND HE YEARNED FOR.

That all changed the morning we woke up together, snuggled in the back of my 4Runner. We spent the night camping, surrounded by the most spectacular mountains, with no one around except the wildlife, thanks to a local's tip earlier that day. Baloo settled right in, getting so cozy and deep in my sleeping

bag that I almost forgot that he had never done this before! He seemed like a pro, copying Henry's every move, acting way more like a dog than a cat.

Naturally waking up with the sun, I reached down into my sleeping bag and pulled out a really warm, happy Baloo, who may have wanted to sleep a little bit longer. I'll never forget how Henry's face lit up when he saw Baloo come out of my sleeping bag that morning. Jumping up and bursting with excitement that his new little buddy was actually here, camping with us, he rushed right over and gave B the biggest kiss. Henry finally found his forever friend, just as Baloo had found in him.

If Henry and Baloo thought the day couldn't possibly get any better, they were in for a real treat because the trail we were about to hike was pulled straight out of a fairytale. Endless mountain views, streams, waterfalls, and wildflowers entertained us the whole way up, dead-ending into the most mesmerizing alpine lake. Henry didn't miss a beat, leaping into the icy blue water as fast as he could, while Baloo and I found a spot to hang out and soak in the views we had worked so hard to see.

As Baloo and I were watching Henry have a ball swimming in the water, a bald eagle flew over us, circling the lake until it dove in to catch a fish. "How crazy is that, guys?!" I said, looking to Henry and Baloo. You only get to see that sort of thing in documentaries, but not in real life—how lucky were we? Once our live nature show was over (which had put a cherry on top of the best day), we started hiking down the mountain.

It was time to go back home to Denver, but I don't think any of us really wanted to leave. This place was just so magical and brought us all closer together. I seriously never thought I would see Henry love anything more than exploring the outdoors, until he got to explore the outdoors with Baloo. As soon as that happened, B became the most important thing in his life, and I think it will forever remain that way. I know it's hard to understand, not knowing Henry, but trust me—I really thought I would never see the day when something or someone was more important to him than Mother Nature. Thanks, Baloo, for being the best friend Henry could ever ask for.

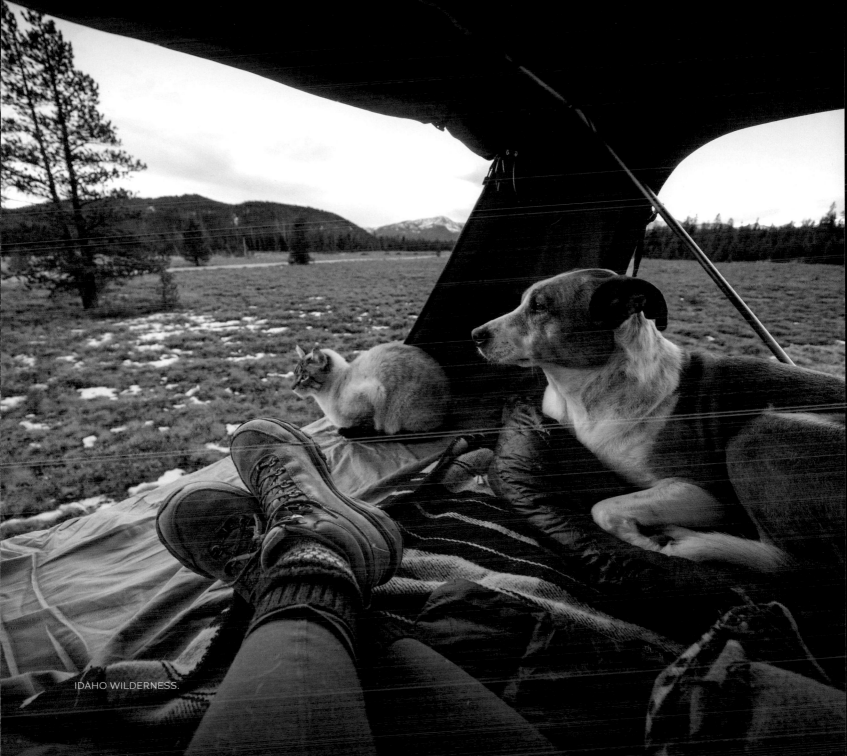

IDAHO WILDERNESS.

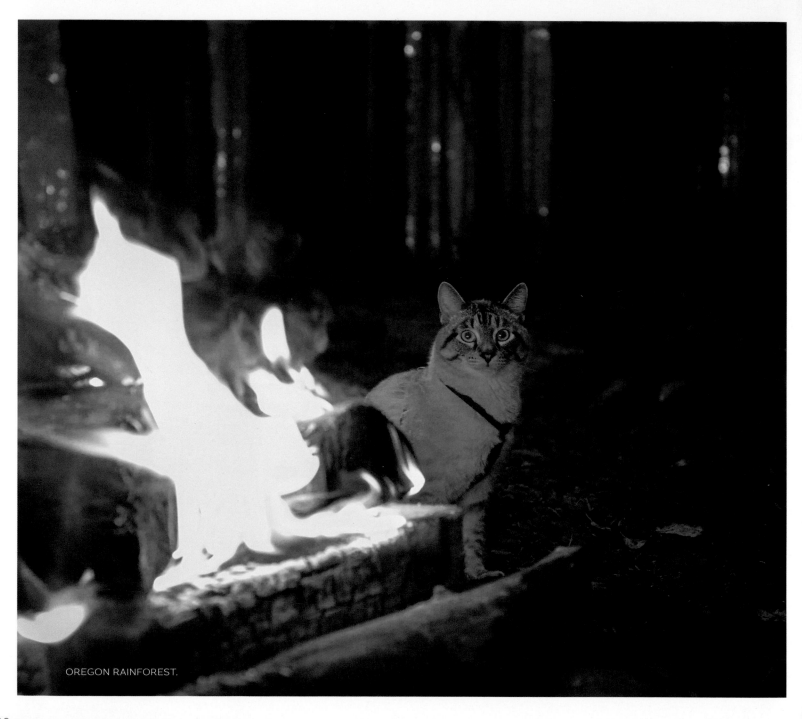

OREGON RAINFOREST.

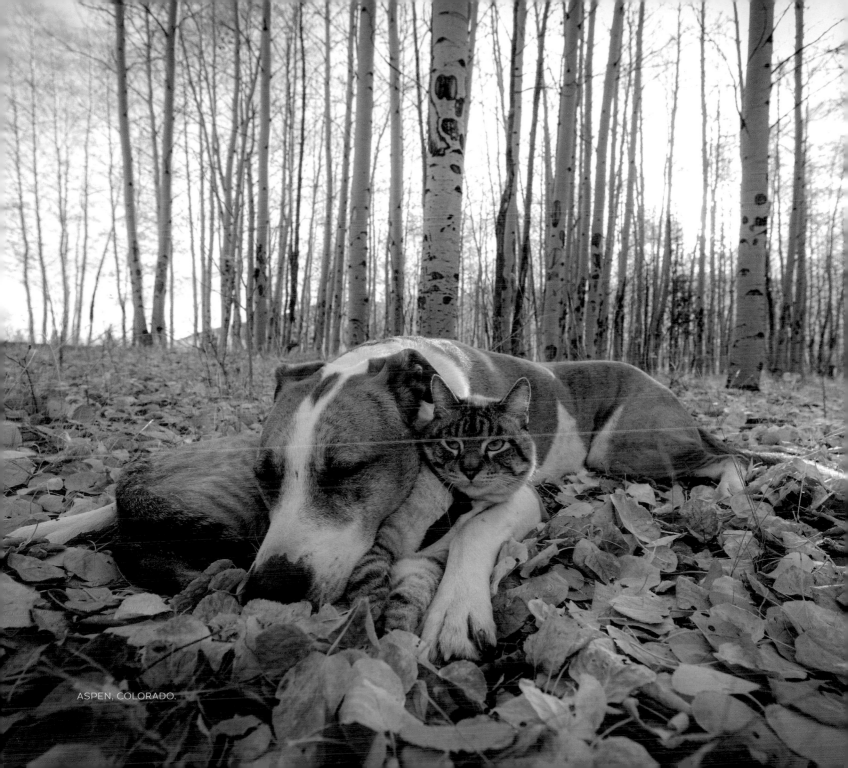

ASPEN, COLORADO.

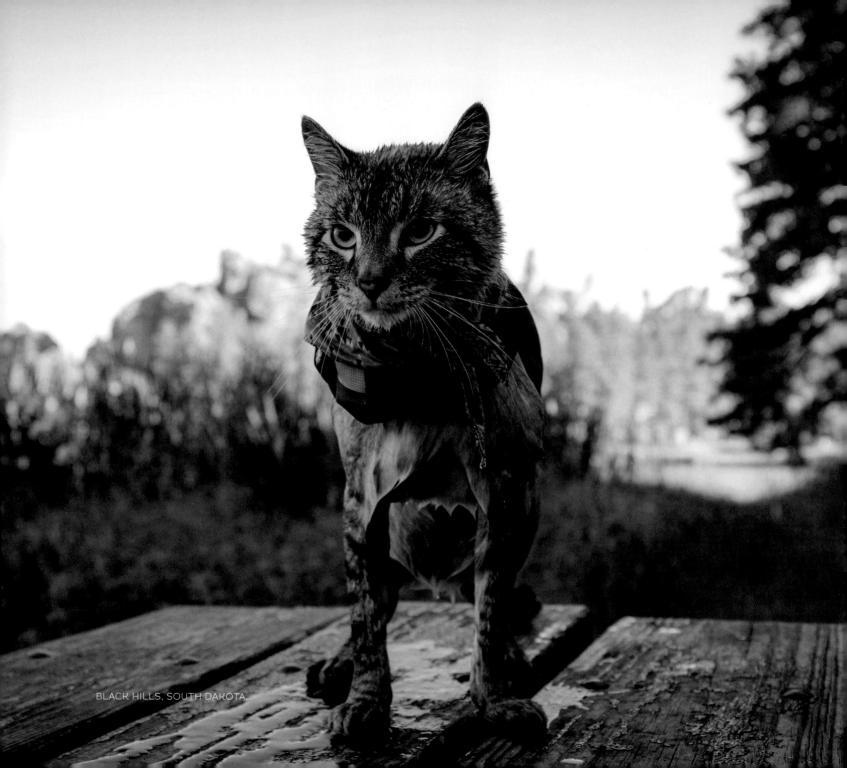

BLACK HILLS, SOUTH DAKOTA.

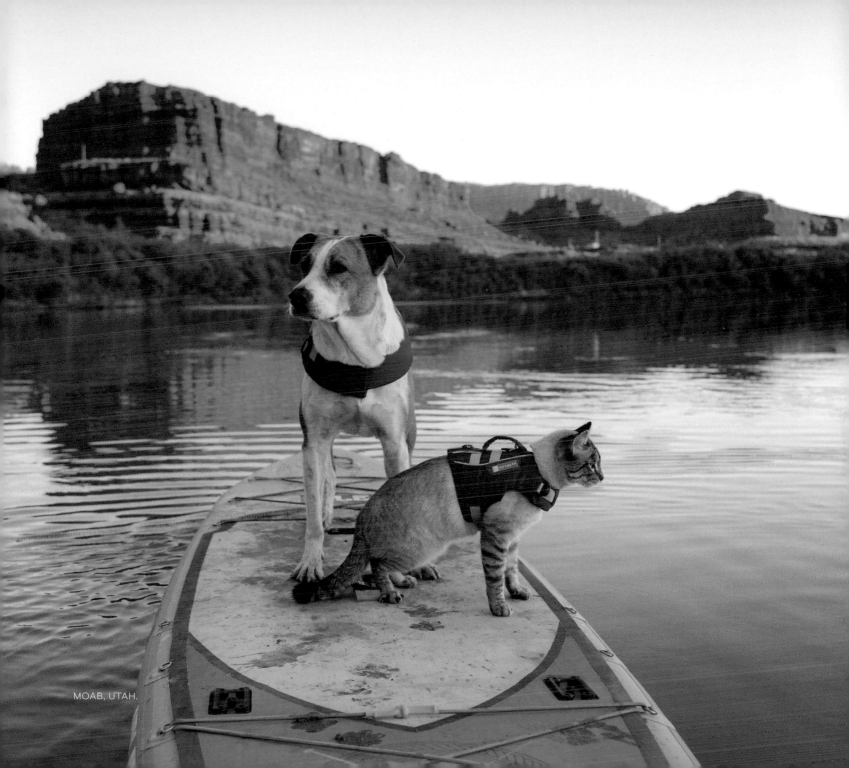

MOAB, UTAH.

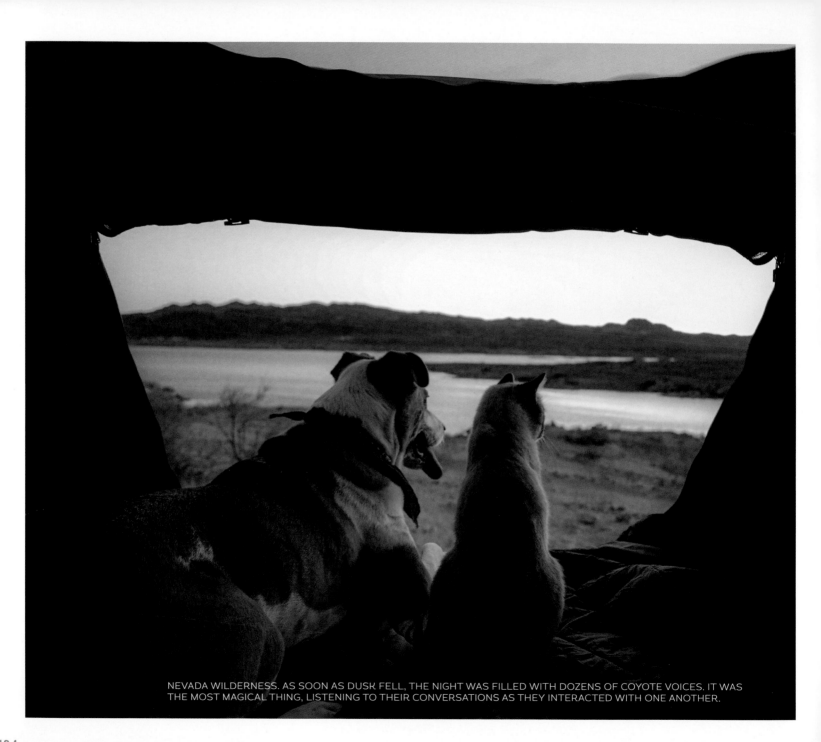

NEVADA WILDERNESS. AS SOON AS DUSK FELL, THE NIGHT WAS FILLED WITH DOZENS OF COYOTE VOICES. IT WAS THE MOST MAGICAL THING, LISTENING TO THEIR CONVERSATIONS AS THEY INTERACTED WITH ONE ANOTHER.

ONLY THE WILD ONES

are the ones you can never catch.

STARS

ARE UP NOW,

no place to go, 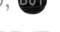 **EVERYWHERE.**

—DISPATCH
"Only the Wild Ones"

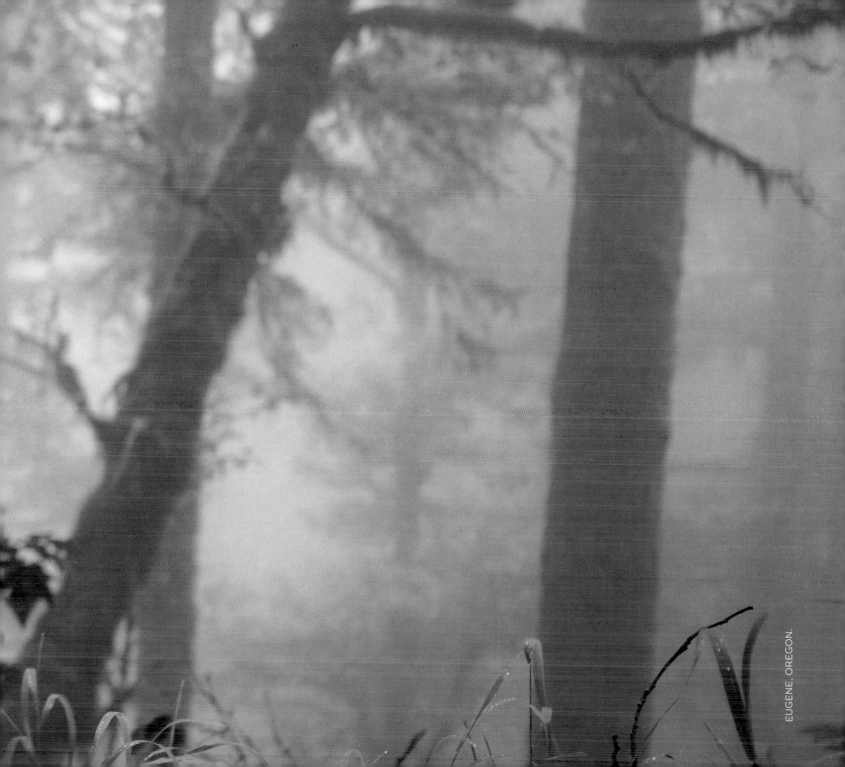

EUGENE, OREGON.

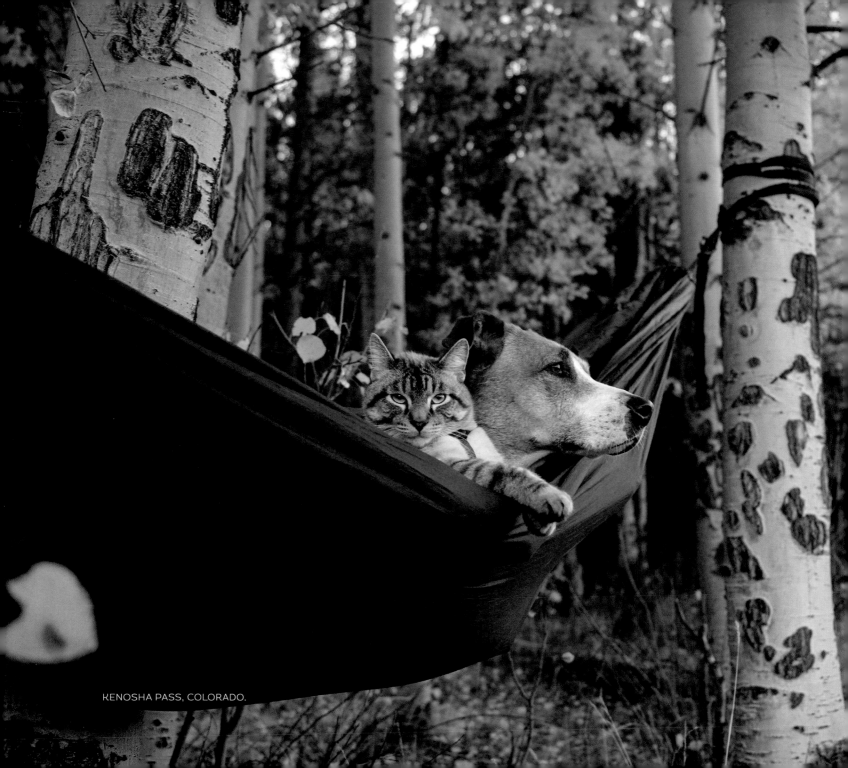

KENOSHA PASS, COLORADO.

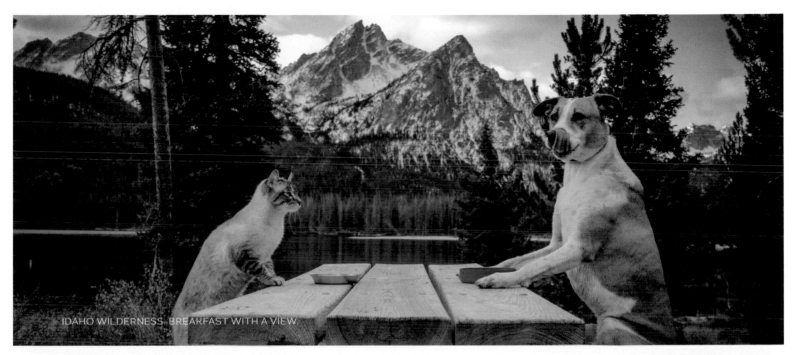

IDAHO WILDERNESS. BREAKFAST WITH A VIEW.

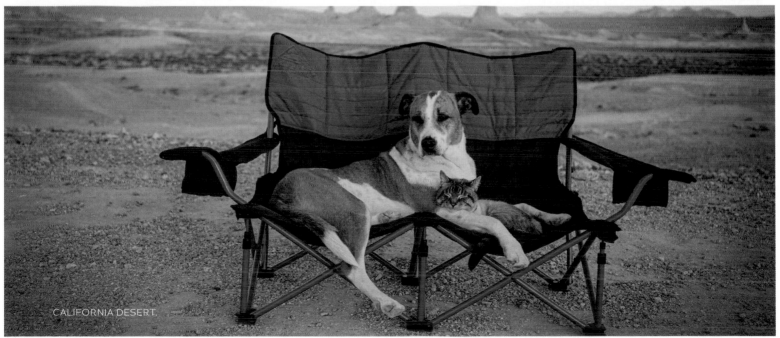

CALIFORNIA DESERT.

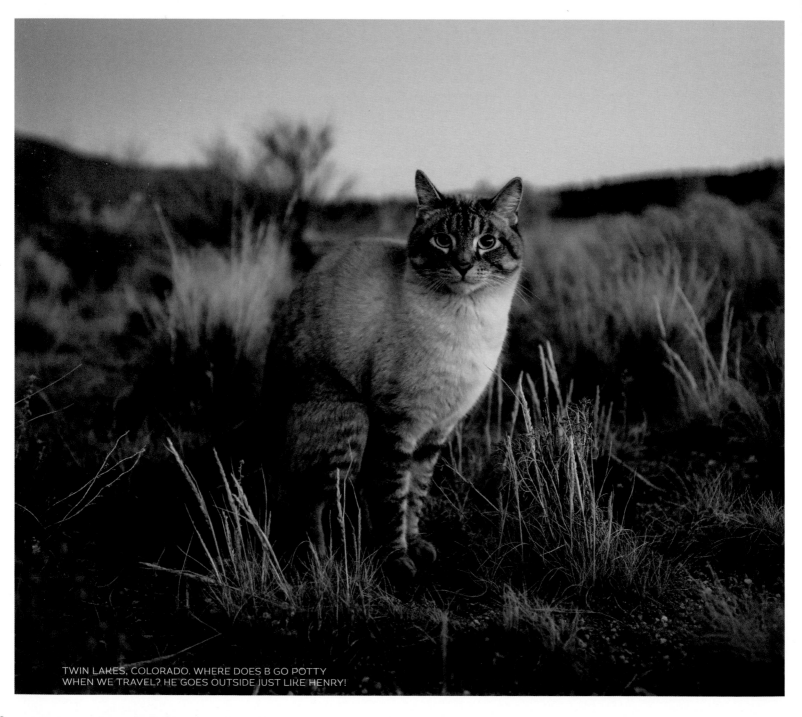

TWIN LAKES, COLORADO. WHERE DOES B GO POTTY
WHEN WE TRAVEL? HE GOES OUTSIDE JUST LIKE HENRY!

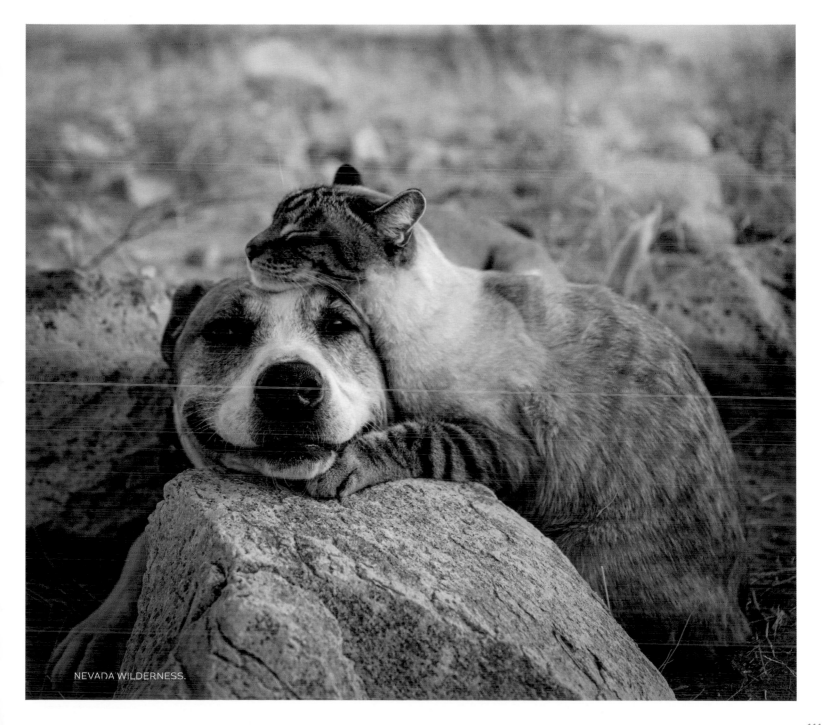

NEVADA WILDERNESS.

I WAS BORN

by the river, in a little tent.

AND JUST LIKE THE

RIVER,

I'VE BEEN RUNNING

EVER SINCE.

—THE NEVILLE BROTHERS

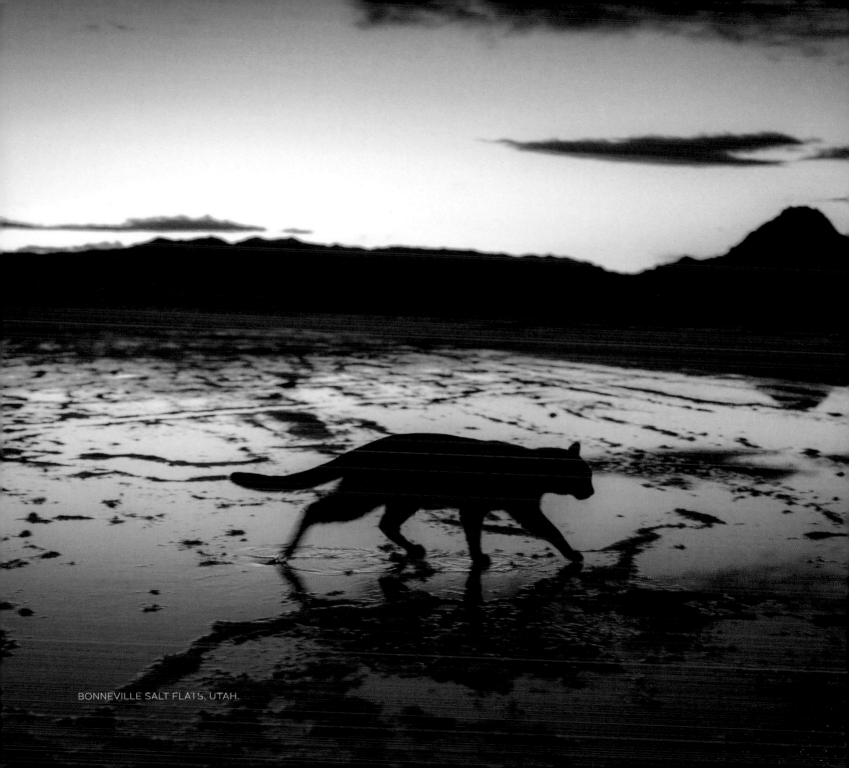

BONNEVILLE SALT FLATS, UTAH.

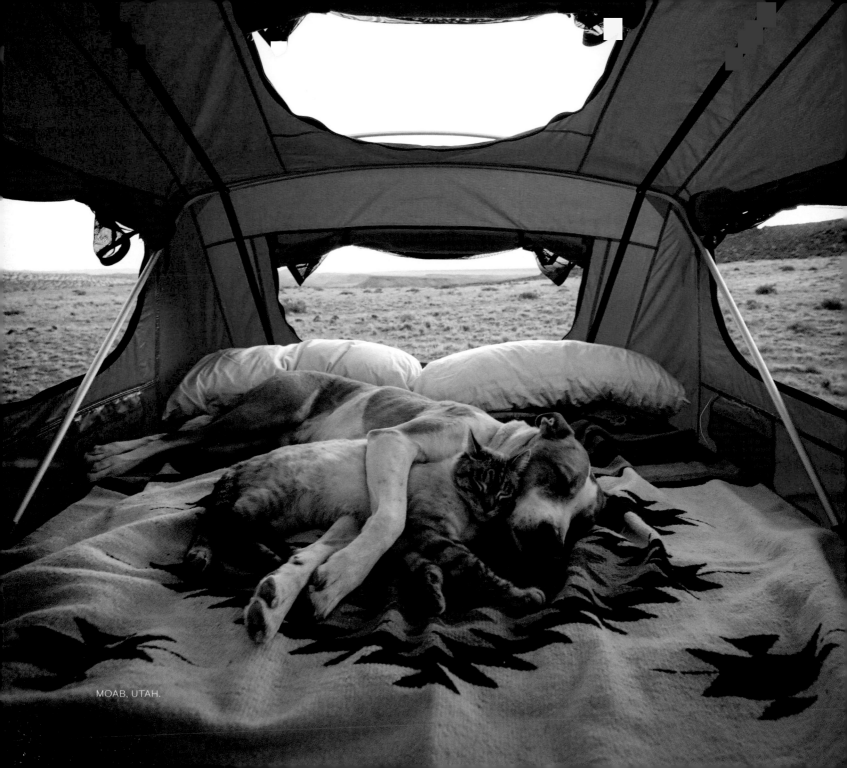

MOAB, UTAH.

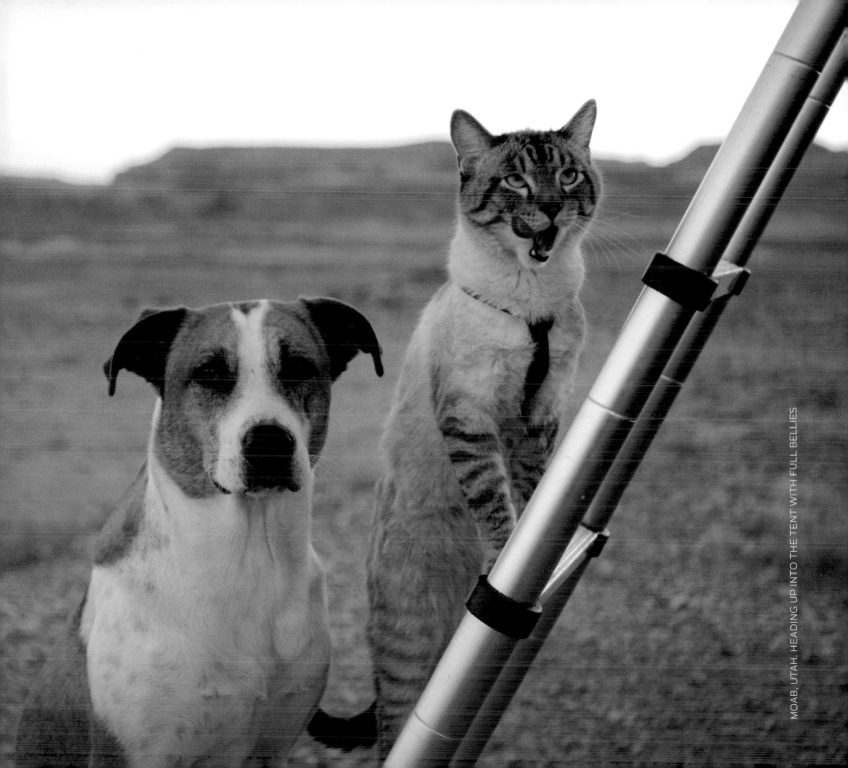

9 YEARS
— LATER —

HENRY AND BALOO ARE CLOSER THAN EVER AND ARE STILL GOING ON ALL SORTS OF ADVENTURES IN COLORADO AND THROUGHOUT AMERICA'S GREAT WEST.

They've stood on top of a 14,036-foot Colorado peak, they've paddleboarded through canyons in the Utah desert, they've frolicked through alpine meadows in Wyoming, they've dipped their toes in the Pacific Ocean in California, and they've even taken the ferry to Mackinac Island in Michigan, relying on each other every step of the way!

Somehow, we got really, really lucky with these two, and somehow they both were a perfect fit for the other. Whatever reason brought us all together, I'm glad it did, because I can't even begin to imagine a life without them. We love you so much, Henry and Baloo, and we'd take you to the moon and back if we could.

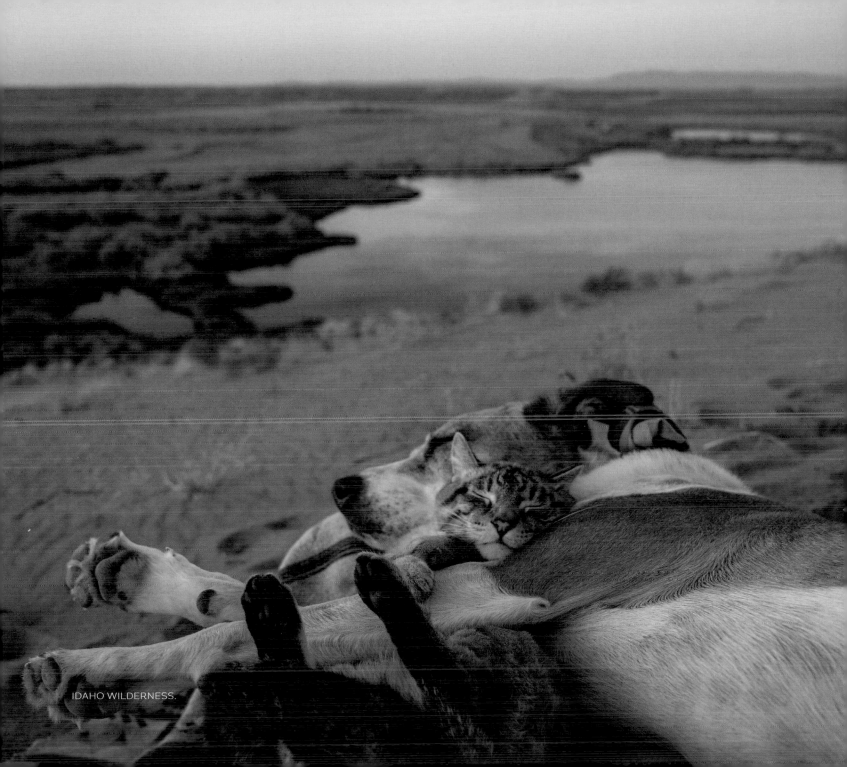

IDAHO WILDERNESS.

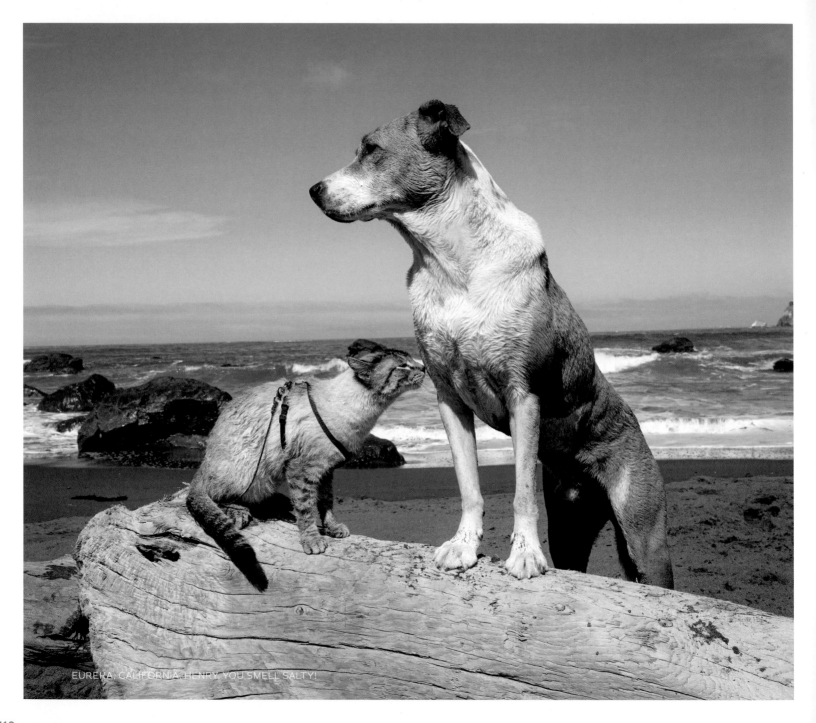

EUREKA, CALIFORNIA. HENRY, YOU SMELL SALTY!

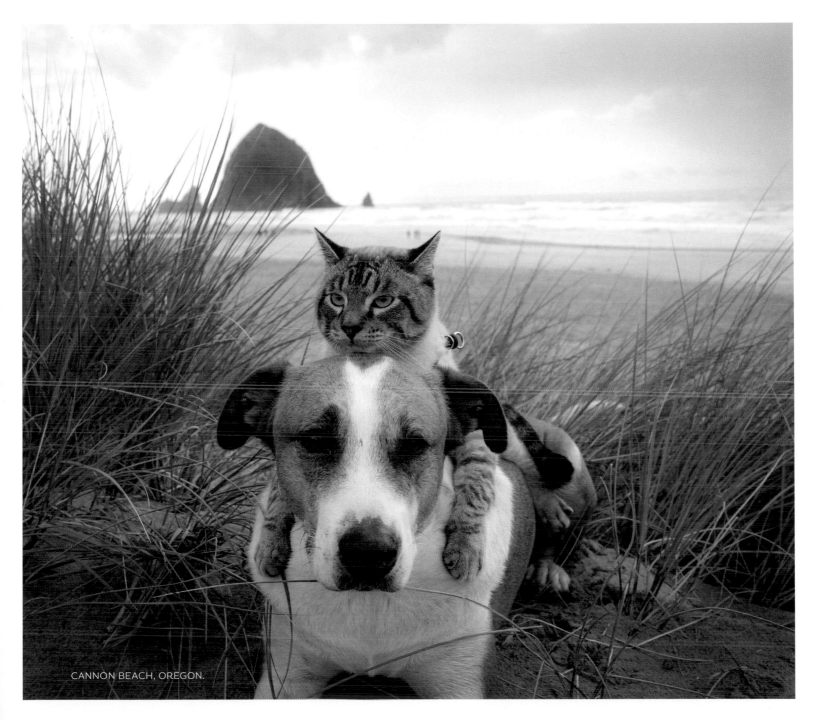

CANNON BEACH, OREGON.

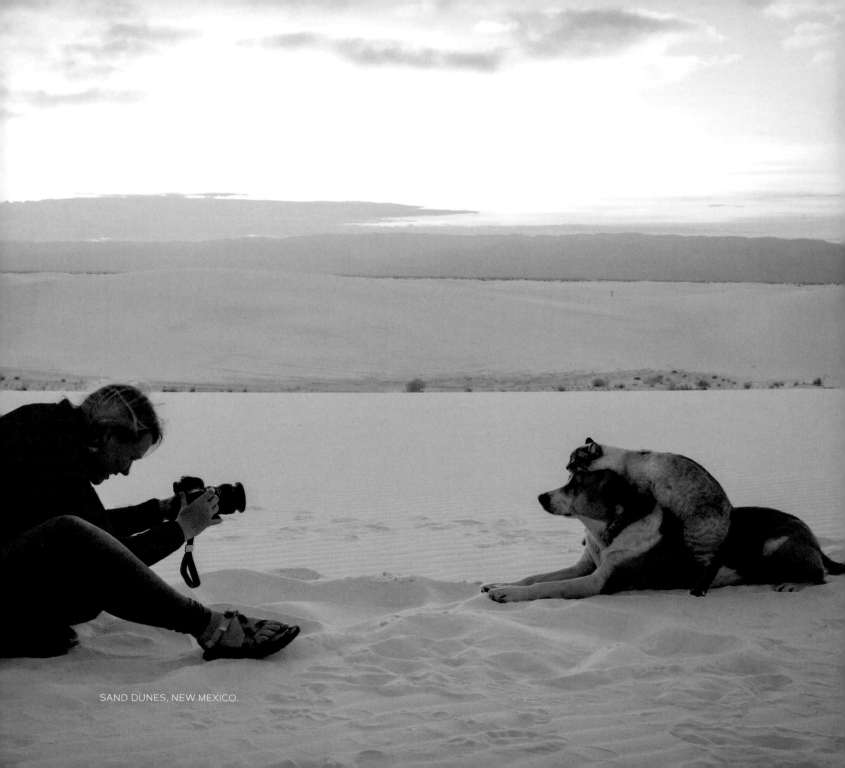

SAND DUNES, NEW MEXICO.

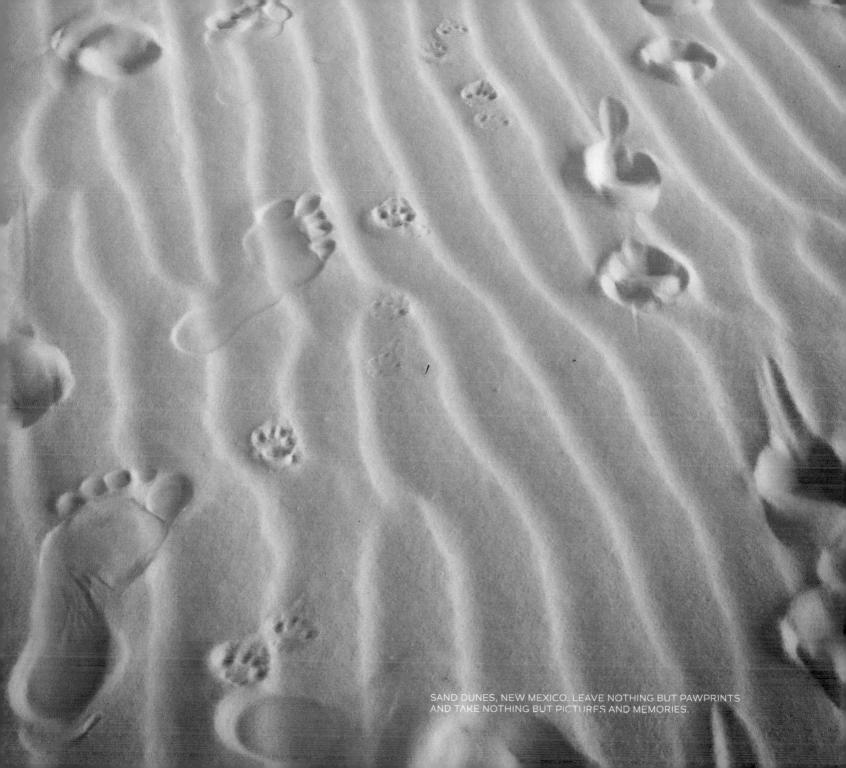

SAND DUNES, NEW MEXICO. LEAVE NOTHING BUT PAWPRINTS
AND TAKE NOTHING BUT PICTURES AND MEMORIES.

THE CLEAREST WAY

into the

UNIVERSE

is through a

FOREST WILDERNESS.

—JOHN MUIR

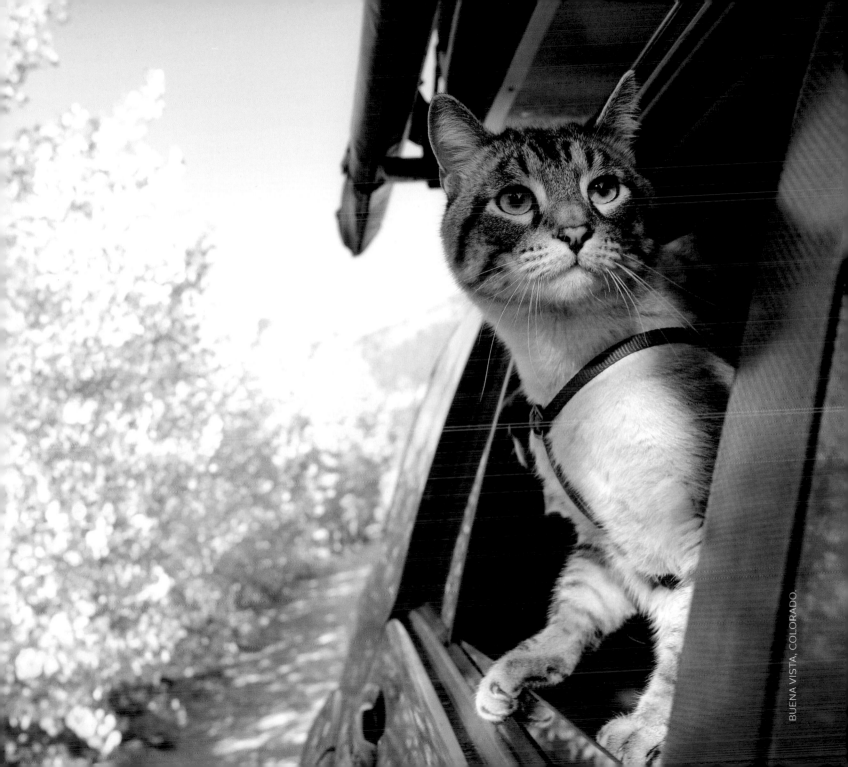

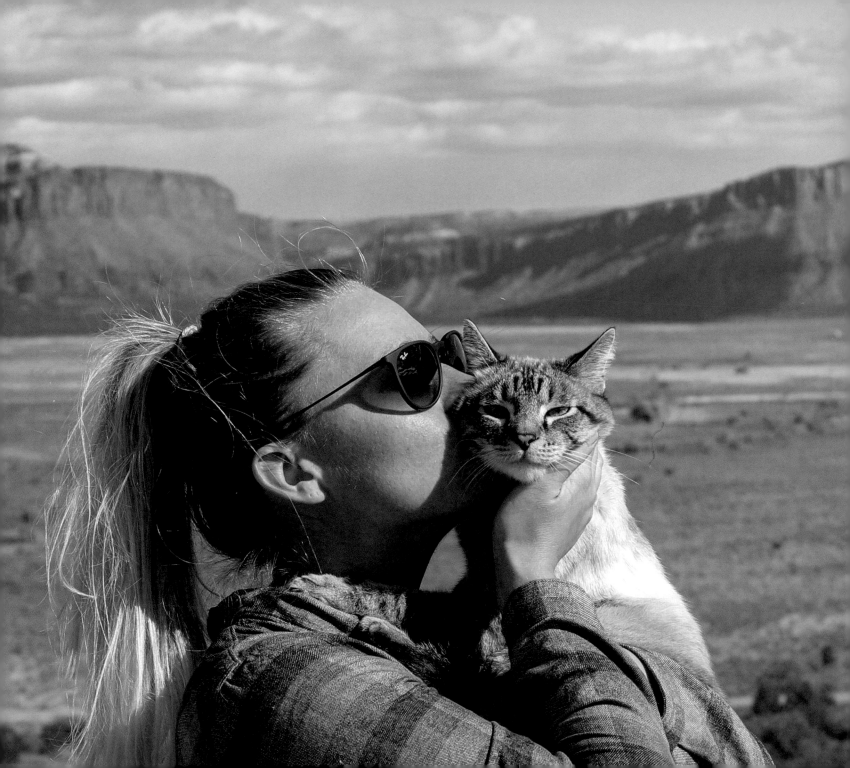

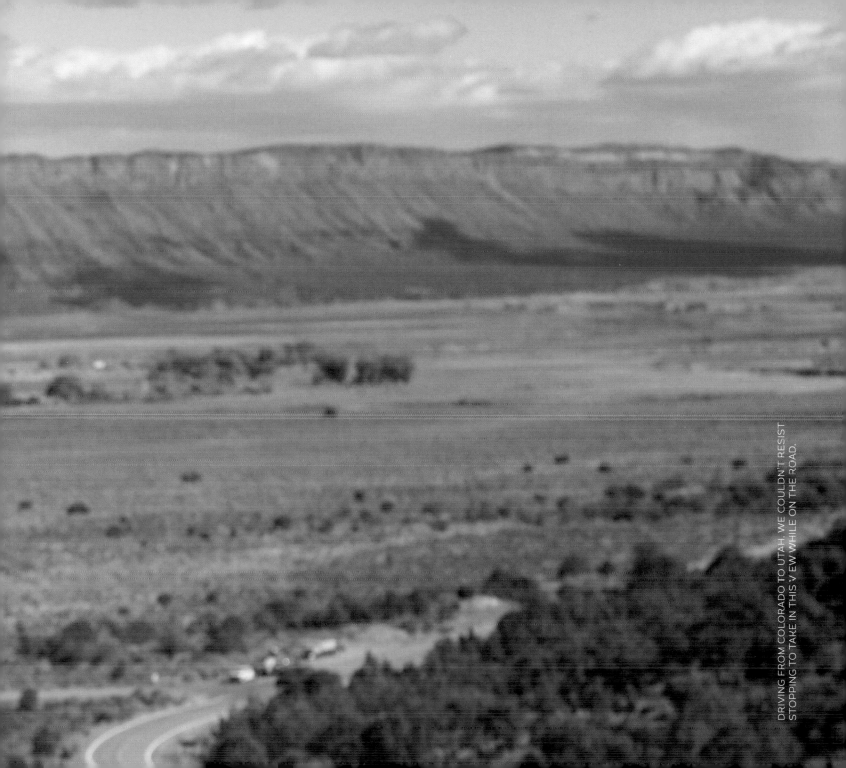

DRIVING FROM COLORADO TO UTAH, WE COULDN'T RESIST STOPPING TO TAKE IN THIS VIEW WHILE ON THE ROAD.

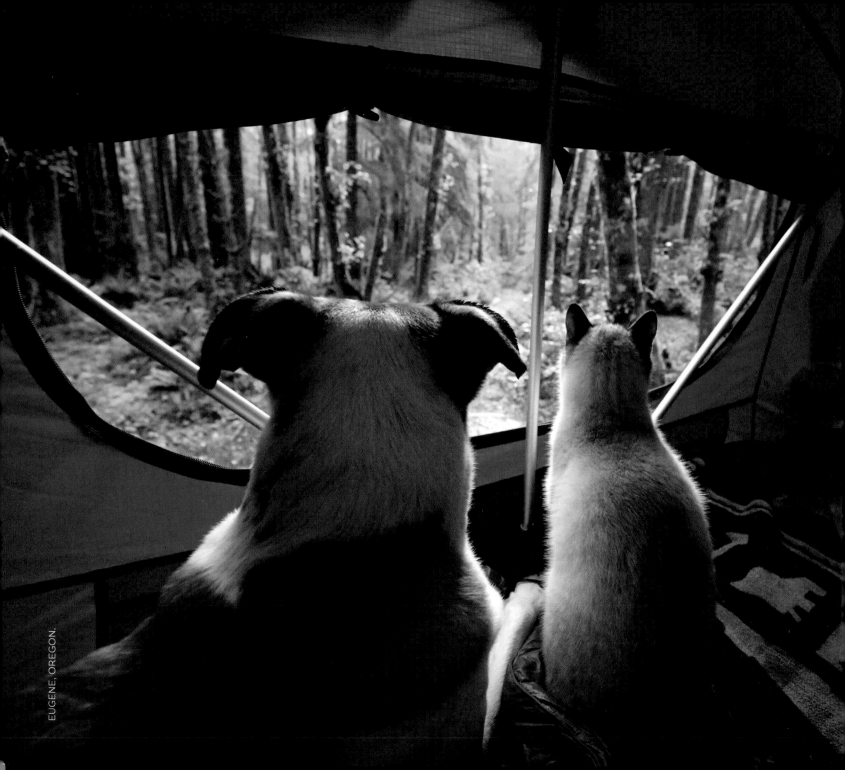

EUGENE, OREGON.

THERE IS

PLEASURE

IN THE

PATHLESS

woods.

—LORD BYRON

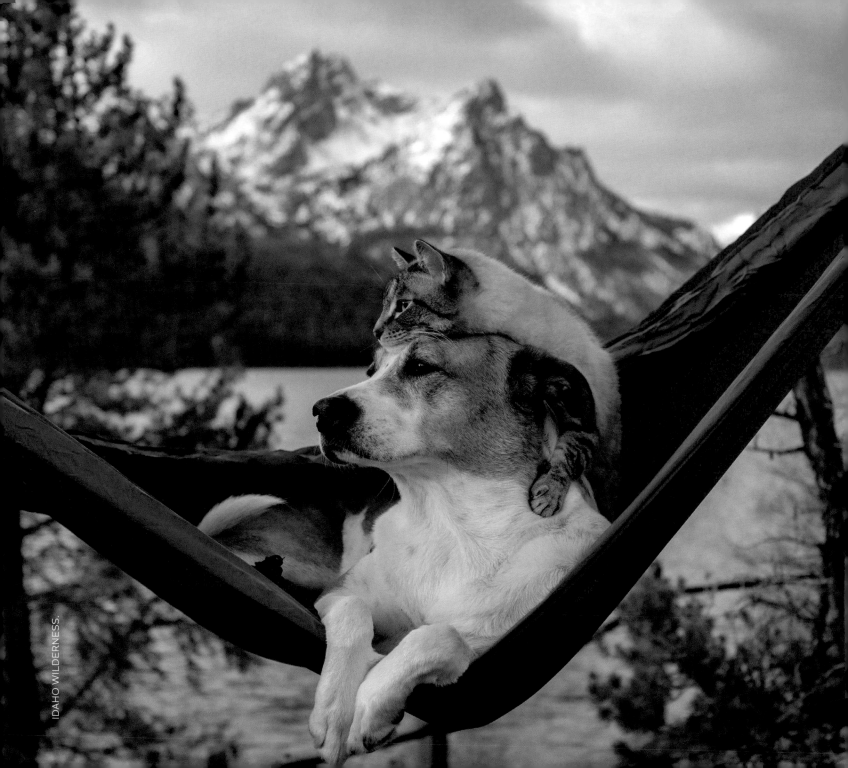

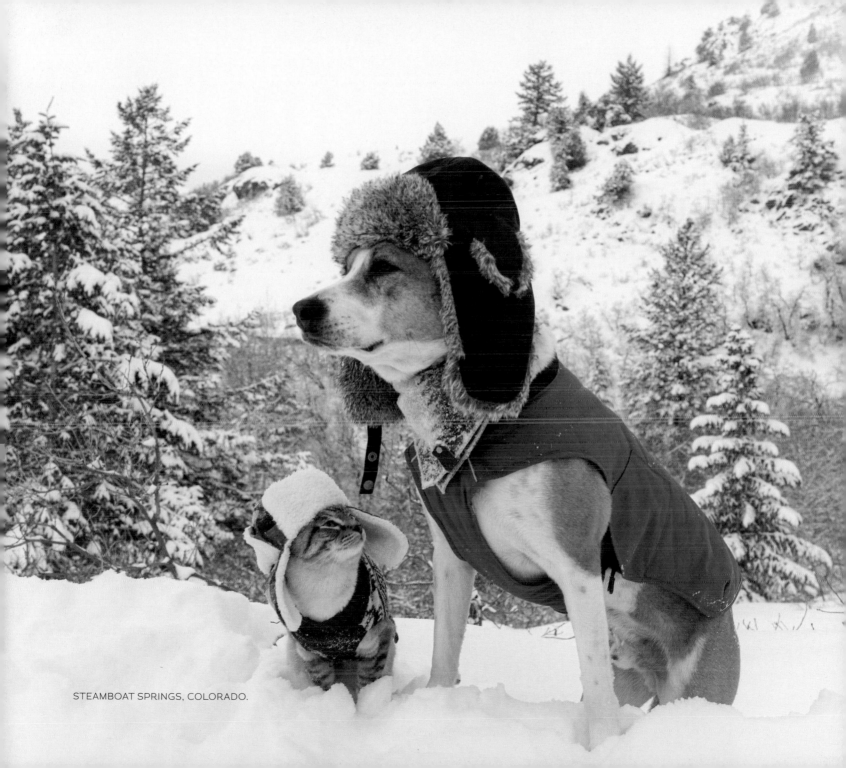

STEAMBOAT SPRINGS, COLORADO.

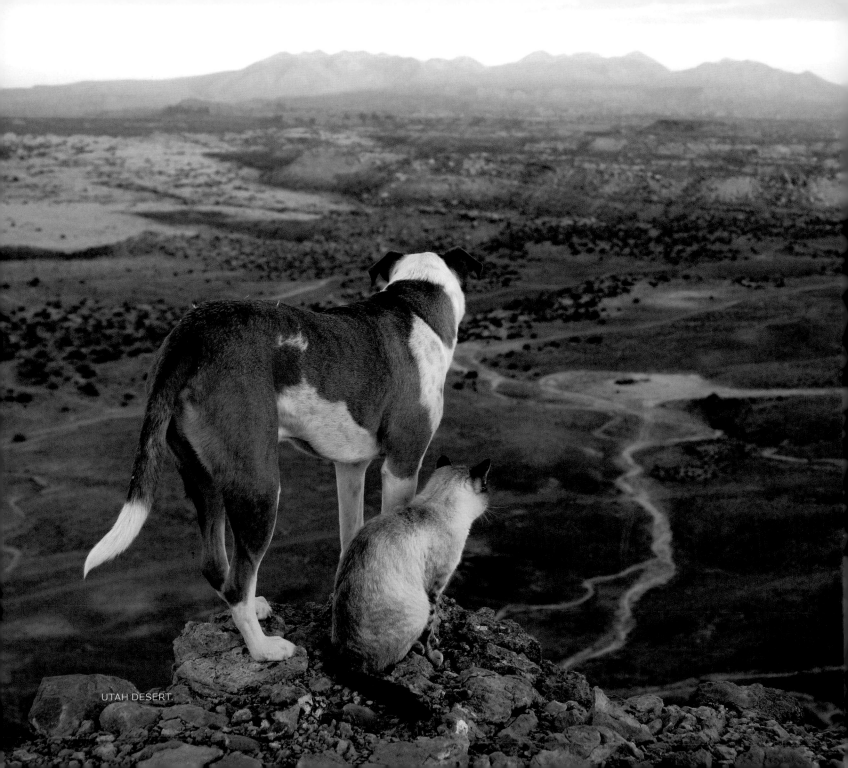

UTAH DESERT.

IT'S

AMAZING

THE DIFFERENCE

A bit of sky can make.

—SHEL SILVERSTEIN

MACKINAW CITY, MICHIGAN.

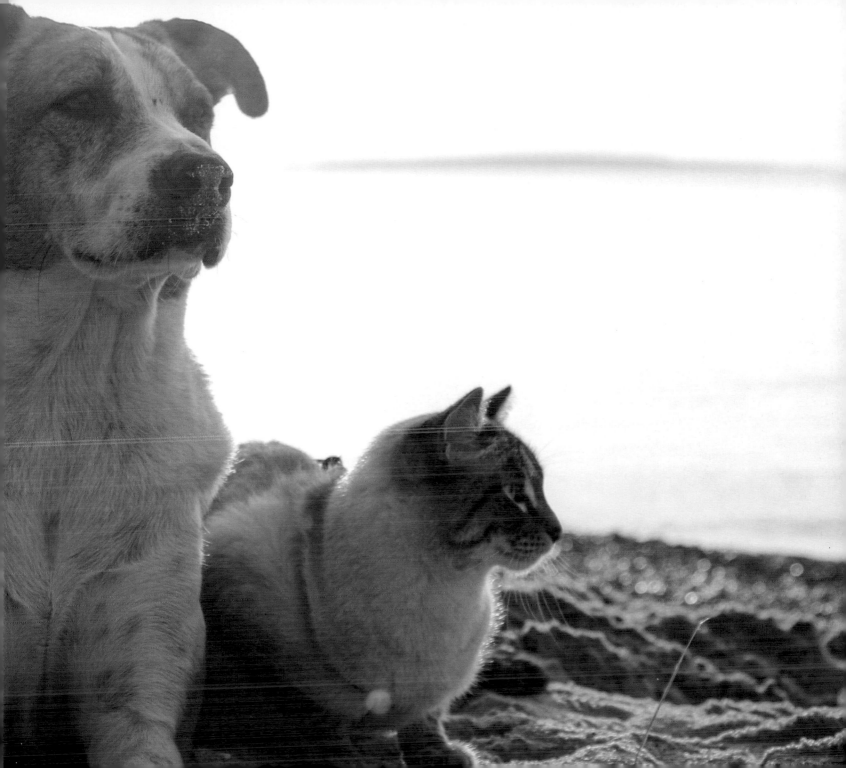

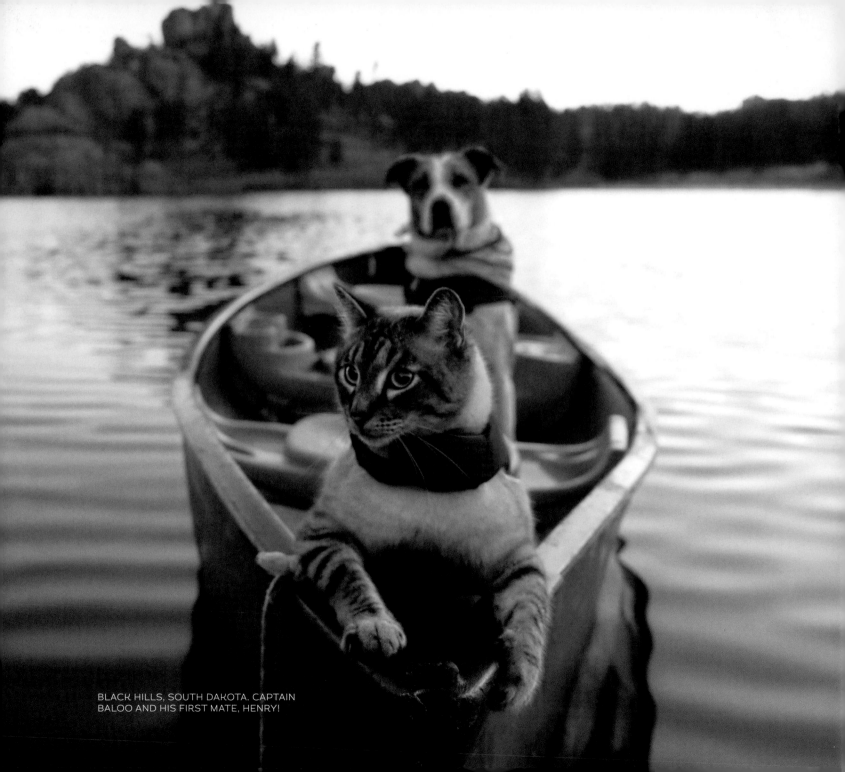

BLACK HILLS, SOUTH DAKOTA. CAPTAIN
BALOO AND HIS FIRST MATE, HENRY!

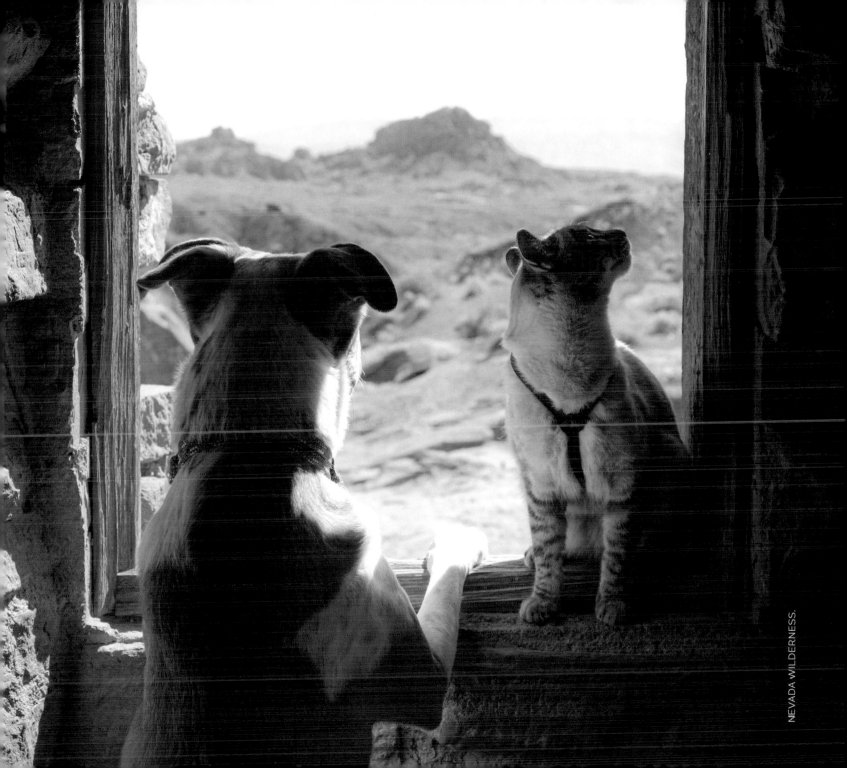

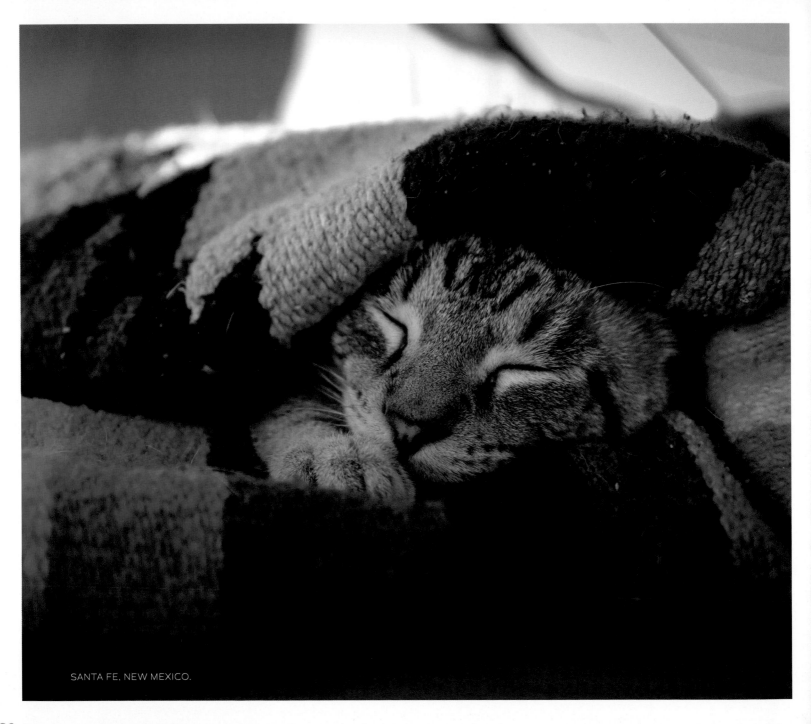

SANTA FE, NEW MEXICO.

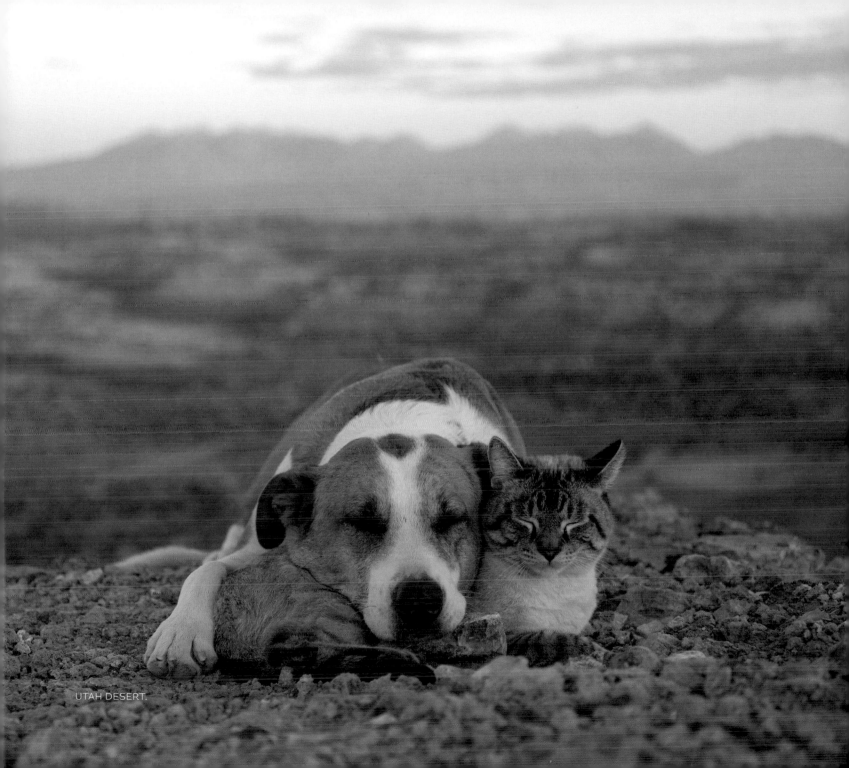

UTAH DESERT.

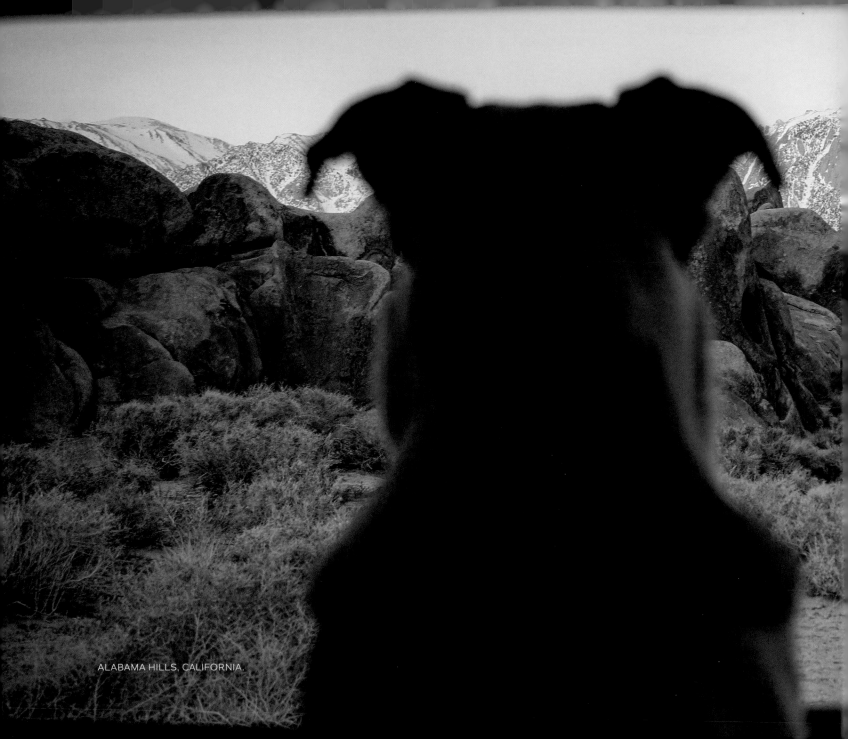

ALABAMA HILLS, CALIFORNIA.

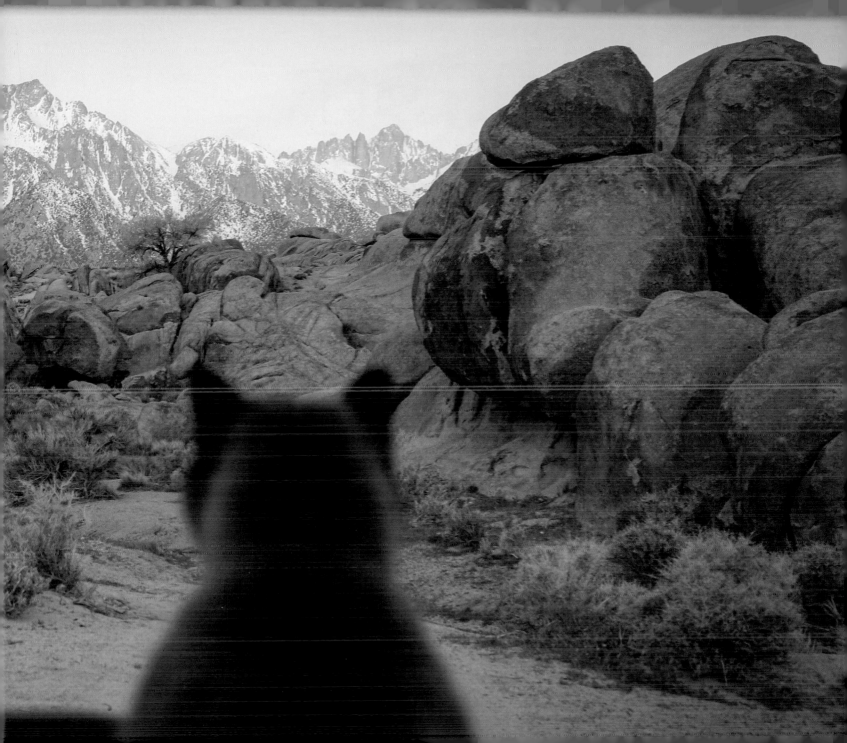

FUN FACTS

———

HENRY ADOPTED: NOVEMBER 2014
BALOO ADOPTED: SEPTEMBER 2017

HENRY'S BIRTHDAY: AUGUST 8, 2014
BALOO'S BIRTHDAY: JULY 9, 2017

HENRY'S NAME: We gave him the name Henry because of the way he carries himself, almost like a person. He's extremely loyal, intelligent, confident, and will do anything for his pack.

BALOO'S NAME: We named Baloo after the bear in *The Jungle Book* because of his carefree, but adventurous attitude. Every time I looked at Baloo, *The Bear Necessities* song played in my head!

Henry's rescue originally thought he was a girl and named him Buttercup, poor guy!

Henry and Baloo have been to fourteen different states and hope to see them all one day with the exception of Hawaii.

ALIASES

HENRY:
Henricans, Bubba, Sir Henry, Goober,
Snufflelupagus, Snugglkins,
Little Mountain Goat

BALOO:
Mr. Baloo, Kitty Cream Cheese,
Baby Baloo, B, Munchkin, Parrot Kitty,
Balooga

THANKS FOR READING
To see what Henry & Baloo are up to next,
follow along on Instagram:

@HENRYTHECOLORADODOG

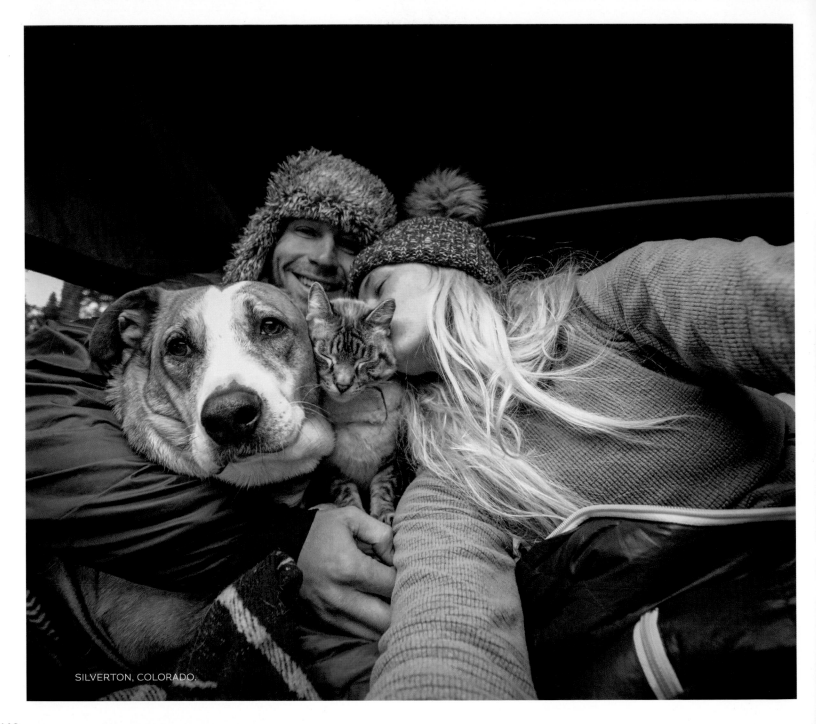

SILVERTON, COLORADO.

ABOUT

THE AUTHOR

CYNTHIA BENNETT IS

A photographer and animal lover with an affinity for long trails and wildflowers. Most importantly, she's a mother to her dog, Henry, and cat, Baloo.

In 2018, she founded Our Wild Tails to share the story of universal love shown by her animals and to help preserve our unprotected land.

She currently lives in Denver, Colorado, with her partner, Andre Sibilsky. They spend their days with Henry and Baloo, chasing light and moments in the Rocky Mountains.

FIRST EDITION
24 23 22 21 20 1 2 3 4 5

———————

TEXT & PHOTOGRAPHS ©2020

CYNTHIA BENNETT

Published by GIBBS SMITH
P.O. Box 667 Layton, UT 84041

1.800.835.4993 ORDERS
www.gibbs-smith.com

———————

DESIGNED BY NICOLE LARUE

PRINTED & BOUND IN CHINA

Gibbs Smith books are printed on either recycled, 100% post-consumer waste, FSC-certified papers or on paper produced from sustainable PEFC-certified forest/controlled wood source. Learn more at www.pefc.org.

LIBRARY OF CONGRESS CONTROL NUMBER: 2020933158

ISBN-13: 978-1-4236-5405-6

———————